Encyclopedia of
LIVING ARTISTS

Fantasy by Marnie Johnson

Lollipop Factory by Mark A Yamin

Encyclopedia of
Living Artists

Masks II: The Joybringer by Gayle Pritchard

10th Anniversary Edition

Untitled by Glory Tacheenie-Campoy

Editor: Constance Smith
Design: Laura Ottina Davis

Front cover: *Metal Man* by Robert G Bertone
Back cover: *The Annunciation of the Virgin Mary (Insert God Here)* by Mark T Smith
Copyright © 1997 ArtNetwork

The *Encyclopedia of Living Artists, 10th Edition* serves the needs of professional members of the artworld, connecting artists to buyers of fine art.

ArtNetwork, PO Box 1268, 18757 Wildflower Dr, Penn Valley, CA 95946
916·432·7630 916·432·7633 Fax
http://oro.net/~artnetwo/home.html http://www.scultura.com
E-mail: artnetwo@oro.net

All rights reserved. No images in this book may be reproduced or utilized many form or by an means, electronic or mechanical, including photocopy recording or by any information storage and retrieval systems without written permission from the artist.

Main entry under title:
Encyclopedia of Living Artists
 1. Artists - Biography
 1. Art, Modern - 20th Century

ISBN: 0-940899-33-7

Printed in Hong Kong

Over the past ten years the *Encyclopedia of Living Artists* has proved to be a powerful tool for many artists. It has been providing consultants, publishers, galleries, museum curators, interior designers and collectors with a source to make more intelligent choices.

This tenth anniversary edition will introduce, and in several cases reintroduce, some of the best artists around the country. You will find artists with a variety of styles, mediums and philosophies, satisfying diverse artworld needs. Some artists are internationally recognized, some regionally, others are yet to emerge.

For your convenience we have placed the artists' biographical information in alphabetical order at the end of the book. Three indexes are available for easy reference—medium, geographical and alphabetical.

If an artist's work arouses your interest while browsing, call them. They will have similar pieces in the style displayed that might intrigue you even more. They will be glad to send you photos or slides of other samples of their work.

This was the third year of our cover contest. We received more than 1500 entries from 350 artists. The many entries reaffirmed the limitless range of creative expression amongst fine artists. Congratulations to the grand-prize winner, Robert G Bertone from New Jersey and to the first runner-up, Mark T Smith from New York. We also have several 'honorable mention' works scattered throughout this edition.

We hope you will use this issue to reference fine artists that you normally would not be able to locate. Keep us posted to the results of your inquiries. Support a living artist this year by contacting someone in this directory!

Constance Smith

My Corinthian Capitals Always Look Like Pineapples by Julie M^cGuire

GEORGE ALPHONSO WALKER

Heaven and Earthly Watch Oil, 28x22"

2864 Broadway, San Diego, CA 92102 619·239·8058 73 E 96th St #11B, Brooklyn, NY 11212
Represented by Darin Kaye, 75 West End Ave #P24B, New York, NY 10023 212·764·2500

Encyclopedia of Living Artists, 10th Edition

PHILIP SHERROD

Ms. Ricco..Goes-To..(MANHATTAN!)? Oil on canvas, 80 1/2 x 60 1/2"

41 W 24th St, New York, NY 10010 212·989·3174
Represented by *Allan Stone Gallery*, 113 E 90th St, New York, NY 10128

WENDY LANE

Cattails 1994
Oil pastel, conte, crayon on paper, 30x22 "
Minnesota River Drainage 1994
Oil pastel on paper, 30x22 "

275 E Fourth St, Northwestern Bldg, Studio 820
St Paul, MN 55101-1628 612·802·0688 612·224·1820 Fax

Encyclopedia of Living Artists, 10th Edition · 9 ·

JAMES EUGENE ALBERT

Hard Boiled Iris ink on 100% rag paper, 20x28"

601 Van Ness Ave #E3518, San Francisco, CA 94102-3200 415·776·6632 415·776·6761 Fax

Encyclopedia of Living Artists, 10th Edition

JAMES EUGENE ALBERT

Strange Yellow Room Iris ink on 100% rag paper, 24x24"

601 Van Ness Ave #E3518, San Francisco, CA 94102-3200 415·776·6632 415·776·6761 Fax

Encyclopedia of Living Artists, 10th Edition

ERNIE APPLEWHITE

Envision Computer, 11x14"
9612 Ferry Point Rd, Gautier, MS 39553-1924 601·497·1290 601·762·4173 Fax

LUDMILA GAYVORONSKY

The End of My World
Oil on canvas, 36x36"

26 Church St #5, Newport, NH 03773
603·863·9919

· 12 · Encyclopedia of Living Artists, 10th Edition

Printed in Hong Kong © ArtNetwork Press

ROSEMARY HENDLER
Pear and Straw Computer, 24x28"
16 Verano Rd, Orinda, CA 94563 510·254·9178 510·253·9623 Fax

Encyclopedia of Living Artists, 10th Edition · 13 ·

EVA KEKY-MAGYAR

Going Together Encaustic/glass, 56x46"

Szombathely Kilato-ut 12, H-9700 Hungary 36994·315·910

· 14 · *Encyclopedia of Living Artists, 10th Edition*

EVA KEKY-MAGYAR

Uniting Heaven and Earth Encaustic/glass textile, 46x56 "
Szombathely Kilato-ut 12, H-9700 Hungary 36994·315·910

Encyclopedia of Living Artists, 10th Edition

YVETTE SIKORSKY

Flotilla Acrylic, 36x48"
Maui Acrylic, 36x48"

PO Box 146, Lake Mohegan, NY 10547-0146 914·737·5167

Encyclopedia of Living Artists, 10th Edition

NANCY DELGADO

A Little Worse for Wear Watercolor, 12x19"

PO Box 471, Forks, WA 98331 360·374·6885

Encyclopedia of Living Artists, 10th Edition

ALVIN C HOLLINGSWORTH

Phenomenal Woman Oil, acrylic and collage, 33x24 "
Masquerade Oil and acrylic, 36x24 "

614 W 147th St, New York, NY 10031

ALVIN C HOLLINGSWORTH

Night in Tunisia Oil, acrylic and collage on wood, 48x58 "
614 W 147th St, New York, NY 10031

Encyclopedia of Living Artists, 10th Edition

CHRIS APOSTLE

Valentine Masquerade Oil on canvas, 48x68"
Toward a New World Order Oil on canvas, 48x68"

PO Box 557, Newtonville, NY 12128-0557
518·462·5113 518·785·5673 Fax

LORNA MASSIE

Veronica's View Serigraph, 20x30"
Moon Cat Serigraph, 26x23"

452 Whitfield Rd, Acord, NY 12404 914·687·7744 Telephone/Fax

Encyclopedia of Living Artists, 10th Edition

HEE SOOK KIM

Iron Woman Artificia2l flowers, gloves, fabric, wood on veneer, 30x14 "
116 Mercer St #5Fl, New York, NY 10012-3806 212·274·0142 Telephone/Fax

BARBARA RACHKO

He Lost His Chance to Flee Pastel on sandpaper, 58x38"

1311 W Braddock Rd, Alexandria, VA 22302-2705 703·998·7496 703·683·5786 Fax

Encyclopedia of Living Artists, 10th Edition · 23 ·

HUMBERTO CHAU

Morning in a Bali Hamlet Oil, 38x46"

42-11 149th Pl, Flushing, NY 11355 718·539·2522

Encyclopedia of Living Artists, 10th Edition

HUGH POLDER

Bark Wanderer Casein, 18x24"
1931 Thompson Casein, 18x23 1/2"

3540 W Beach Ave, Chicago, IL 60651-2201 312·772·7683

Encyclopedia of Living Artists, 10th Edition · 25 ·

FRANK JALSOVSKY
Tribute to Leonardo Intaglio, 25 1/3 x 19 1/3"
1205 Johnson St #209, Coquitlam, BC Canada V3B 7G4 604·941·5621

Encyclopedia of Living Artists, 10th Edition

Printed in Hong Kong © ArtNetwork Press

FRANK JALSOVSKY

Genesis Intaglio, 31²/₃x27"

1205 Johnson St #209, Coquitlam, BC Canada V3B 7G4 604·941·5621

Encyclopedia of Living Artists, 10th Edition

BARBARA GLANDER

Sunset in Acapulco Oil on canvas, 30x60 "

PO Box 31, Columbia, NJ 07832 908·453·4349

BARBARA GLANDER
Sundance Oil on canvas, 30x60"
PO Box 31, Columbia, NJ 07832 908·453·4349

LOUIS F ZYGADLO

If the Walls Could Dance Oil on plastic, 40x72 "
Room with a View Oil on plastic, 40x72 "

403 E 3rd St, Sandwich, IL 60548-1606 815·786·6662
Represented by *Vedanta Gallery*, 119 N Peoria #3C, Chicago, IL 60607 312·432·0708

· 30 · *Encyclopedia of Living Artists, 10th Edition*

TIMOTHY STAFFORD
Jelly Bean Pool Airbrush, 24x22"
926 Hudson St, Hoboken, NJ 07030 201·459·1501

Encyclopedia of Living Artists, 10th Edition

JACK D COWAN

Breakfast in Bed Oil on canvas, 31 1/2x36 1/2"

502 E Anderson St, Orlando, FL 32801 407·426·8291

· 32 · Encyclopedia of Living Artists, 10th Edition

MANABU SAKAGUCHI

The Sweet Sounds Acrylic on canvas, 24x51 "
Misty Acrylic on canvas, 35x57 "

5-11-18-605 Shinjuku, Shinjuku-ku, Tokyo 160 Japan
011·81·3·3356·4108 011·81·3·3357·2416 Fax

Encyclopedia of Living Artists, 10th Edition

IVO DAVID

First Steps Oil on canvas, 30x24"

2027 High St, Union, NJ 07083-3814 908·964·5660 908·688·0490 Fax

MITCHELL GIBSON

Man to Man Acrylic on canvas, 32x38 "
Emergence Acrylic on canvas, 48x36 "

1201 S Alma School #6950, Mesa, AZ 85210
602·644·0050 602·759·6195 Fax

SILJA TALIKKA LAHTINEN

Wild Rivers - Gypsy Violins Silkscreen on arches paper, 15x22 "

5220 Sunset Trail, Marietta, GA 30068 770·992·8380 770·992·0350 Fax

SILJA TALIKKA LAHTINEN

Ritual Intaglio, 15x11"

5220 Sunset Trail, Marietta, GA 30068 770·992·8380 770·992·0350 Fax

Encyclopedia of Living Artists, 10th Edition

MIGUEL BARBOSA

Face of Tragedy Acrylic, 35x24"

Ave Joao Crisostomo 91-2, Lisbon, 1050 Portugal 00351·314·0793
Represented by *Abney Gallery*, 591 Broadway, New York, NY 10012 212·941·8602

· 38 · *Encyclopedia of Living Artists, 10th Edition*

PEGGY ZEHRING

Uxmal Mixed media on handmade paper, 32x72 "
Egyptian Meets Hopi Mixed media on handmade paper, 30x66 "

832 31st Ave S, Seattle, WA 98144 706·328·4825

Encyclopedia of Living Artists, 10th Edition

JACKIE GREBER
Radiance Series II
Plexiglass, mirror and flamed copper, 29x23x2 ¾"
1280 Estes St, Lakewood, CO 80215 303·237·8456

EDWARD HONG LIM
Wake Up the Sleeping Soul Oil, 30x26"
2696 17th Ave, San Francisco, CA 94116
415·664·0709 415·664·0830 Fax

Encyclopedia of Living Artists, 10th Edition

MAREK KOSIBA

Duet Acrylic on canvas, 48x64"
Eva Acrylic on canvas, 48x31"

118 N Peoria #3Fl, Chicago, IL 60607 312·421·2025

Encyclopedia of Living Artists, 10th Edition · 41 ·

MARIA DELIA BERNATE KANTER

Adrienne's Dream Acrylic, 36x60"

6155 La Gorce Dr, Miami Beach, FL 33140 305·865·9406 Telephone/Fax

Encyclopedia of Living Artists, 10th Edition

DEBEE L HOLLAND-OLSON

Evening Light on Limestone Ridge Pastel, 46x37"

224 Main St, PO Box 1805, Weaverville, CA 96093 916·623·2819 916·623·3412 Fax
Represented by *William Zimmer Gallery*, PO Box 263, Mendocino, CA 95460 707·937·5121 707·937·2405 Fax

Encyclopedia of Living Artists, 10th Edition · 43 ·

JUDITA ZILIUS CLOW

Blossom Watercolor, 14x17"
Reflections Watercolor, 14x17"

4 Clayton St, St Johnsbury, VT 05819 802·748·5299 802·748·8324 802·748·4394 Fax

WILLIAM M FEGAN

Living Waters Oil on linen, 56x78"

1316 Conant St, Dallas, TX 75207 214·631·2920 Telephone/Fax

Encyclopedia of Living Artists, 10th Edition · 45 ·

SHIR WOOT0N

Best Ride Ever Pastel, 29x20¾"

117 Granville Ave, Beckley, WV 25801 304·252·5808 304·787·9878 304·255·5041 Fax

Encyclopedia of Living Artists, 10th Edition

ORNA BENSHOSHAN

All for One Oil on canvas, 36x36"
Peachy Dandy Oil on canvas, 40x30"

Represented by *Donna Davis,*
100 Golden Isles Dr #807, Hallandale, FL 33009
954·456·2370

Encyclopedia of Living Artists, 10th Edition · 47 ·

JULIE K NEVA

The Lovers Acyrlic and ink on canvas, 42x44 "
Riomaggiore Acyrlic and wax on canvas, 42x32 "

34081 Pequito Dr, Dana Point, CA 92629
714·248·0157

Encyclopedia of Living Artists, 10th Edition

LUCIANA AMIRGHOLI

A Portrait of Love Acrylic, 48x40"

3012 Silver Spring Ln, Richardson, TX 75082 214·994·0973 214·488·0200 Fax

Encyclopedia of Living Artists, 10th Edition

LISA JONES-MOORE

Summer Reading Pastel, 10x18½"
Domestic Landscape #2 Pastel, 16½x22½"

PO Box 1351, Edmonds, WA 98020-1351 206·774·1432

· 50 · *Encyclopedia of Living Artists, 10th Edition*

FERN L PHILLIPS
Morning Light Oil on canvas, 36x48 "
13791 Hawthorne Blvd, Hawthorne, CA 90250-7016 714·898·8006 310·676·1732 Fax

JANET DELFOSSE
Pink Sky Pastel, 14x17 "
10696 Graeloch Rd, Laurel, MD 20723-1188 301·490·5742

Encyclopedia of Living Artists, 10th Edition

DARNELL LEE

Annie Mae: A Friend Acrylic, 11x8"

PO Box 77752, Atlanta, GA 30357-1752 404·659·8608

· 52 · Encyclopedia of Living Artists, 10th Edition

ZHAOMING WU

Dancing with Illumination Acrylic, 36x48"
Evening Bell Acrylic, 48x36"

529B 42nd St, Oakland CA 94609
510·428·2340

Encyclopedia of Living Artists, 10th Edition

JULIE KRAMER COLE
Circle of the Sacred Dogs Pastel, 17¼x21½"
PO Box 7268, Loveland, CO 80537-0268 970·663·6201 970·663·6485 Fax

SYLVIA OBERT-TURNER
Tres Flores Oil on masonite, 8½x6½"
PO Box 1087, Cochise, AZ 85606
520·384·3061

· 54 · *Encyclopedia of Living Artists, 10th Edition*

DEANNIE MEYER
Tired Out Watercolor, 39 ½ x 31 ½"
1377 Dominion Dr, Redding, CA 96002 916·222·6865

Encyclopedia of Living Artists, 10th Edition

BRUCE BENNETT

Today's Israelis Jerusalem Israel 1991 #2 Ektacolor photography, 6x6 "

1624 Monroe Ave, Rochester, NY 14618-1417 716·271·5052 716·271·2956 Fax

Encyclopedia of Living Artists, 10th Edition

ROBERT KOGGE

Still Life with a Light Colored pencil and wash on canvas, 11x20 "

6603 Blvd East #27, West New York, NJ 07093 201·861·8126

JENNIFER ROTHSCHILD

Football Hero and Fan Watercolor, 25x19"

17 Moloa'a St, Honolulu, HI 96825 808·395·3238 808·395·5334 Fax

JENNETTE BRICE

Hilton Head Beach Acrylic, 24x30"
Roof Tops Acrylic, 34x24"

4301 La Vera St, High Point, NC 27265
910·454·1363
Represented by *Hargis Unique Gallery* 909·623·8977

Encyclopedia of Living Artists, 10th Edition

PATRICIA GEORGE

Positano Oil on canvas, 40x30"

4141 Ball Rd Studio 221, Cypress, CA 90630 714·826·7945 714·995·5149 Fax

· 60 · *Encyclopedia of Living Artists, 10th Edition*

PATRICIA GEORGE

Walkway in Capri Oil on canvas, 36x48"
Miralago Oil on canvas, 40x30"

4141 Ball Rd Studio 221, Cypress, CA 90630
714·826·7945 714·995·5149 Fax

Encyclopedia of Living Artists, 10th Edition

ANN JAMES MASSEY

The Marionette Shop Oil, 20x16"

4, rue Auguste Chabrières, 75015 Paris, France 011·331·4250·7245 011·331·4043·9038 Fax

Represented by *Wyler Gallery*, Holly Denney, 6633 N Mesa #102, El Paso, TX 79912 915·581·8588 915·585·7347 Fax

Encyclopedia of Living Artists, 10th Edition

FRAN BEALLOR

The Date Oil on canvas, 48x30"

839 W End Ave #6F, New York, NY 10025 212·864·7465 212·932·0151 Fax

Encyclopedia of Living Artists, 10th Edition

BATES

Cuttings Oil, 44x20"

PO Box 1405, Basalt, CO 81621 970·927·9363

BATES

Testing Oil, 44x34"

PO Box 1405, Basalt, CO 81621 970·927·9363

SHU-TANG DONG

Boats Acrylic on paper, 16x20"

2473 Casa Wy, Walnut Creek, CA 94596 510·937·9292 Telephone/Fax

WILLIAM M S FANG

Fisherman's Song Acrylic and ink, 26x36"

458 Margueretta St, Toronto, Ont Canada M6H 3S5
416·537·8416 416·537·0435 Fax

JON VAN BRUNT

Love Seat Oil on canvas, 47x42"

216 Putnam Ave, Freeport, NY 11520-1141 516·378·5097

Encyclopedia of Living Artists, 10th Edition

GEORGE E HOMSY

Astronauts Oil on canvas, 10x8"

119 Greenway S, Forest Hills, NY 11375 718·261·5729

· 68 · Encyclopedia of Living Artists, 10th Edition

GEORGE E HOMSY

Upstairs/Downstairs Mixed media on paper, 15x11 "
119 Greenway S, Forest Hills, NY 11375 718·261·5729

Encyclopedia of Living Artists, 10th Edition

DENIS MILHOMME

Dawn Over the Desert Oil, 20x30"

PO Box 988, Three Rivers, CA 93271-0988 209·561·3244

KURT C BURMANN

Pinnacle Peak Planetary Vista Acrylic on canvas, 36x48"

7127 E Becker Ln #2001, Scottsdale, AZ 85254 602·483·1530 602·596·3471 Fax

· 70 · Encyclopedia of Living Artists, 10th Edition

B DOUGLAS DEWAR

The Weigh In Prismacolor pencil, 23x29"

2860 Peninsula Rd #900, Oxnard, CA 93035-4040 805·984·8080

Encyclopedia of Living Artists, 10th Edition

PEGGY PALLETTI
Alchemy Oil pastel on banana bark with metal pieces, 25x38 "
1429 Hemlock, Napa, CA 94559 707·255·9211

LEE PARK
Let Me See Mixed media, 18x24 "
1935 S La Salle Ave #31, Los Angeles, CA 90018 213·735·1778

· 72 · Encyclopedia of Living Artists, 10th Edition

DONNA DUGUAY

Maison pour Deux #8 Oil pastel and mixed media, 29x41 "

PO Box 9492, Berkeley, CA 94709 510·595·7510

Represented by *Harleen & Allen Fine Art*, 427 Bryant St, San Francisco, CA 94107 415·777·0920

Encyclopedia of Living Artists, 10th Edition

BONNIE KWAN HUO

Fair Lady Watercolor, 51x26"

140-8380 Lansdowne Rd #271, Richmond, BC
Canada V6X 1B9 604·271·1833

ALEX MIZUNO

Greetings from Egypt Pastel, 22x15"

140 Harold Ave, San Francisco, CA 94112
415·239·4886 Telephone/Fax

Encyclopedia of Living Artists, 10th Edition

LIDIA SIMEONOVA

I'm Butterfly, You Are.... Acrylic, 42x24"

24575 Greenhill Rd, Warren, MI 48091-1675 810·758·0468
Represented by *Albena Tzonev*, 2973 N Seaton Circuit, Warren, MI 48091

SY ELLENS

View from Above
Acrylic on watercolor paper, 24x19 "

326 W Kalamazoo Ave #304
Kalamazoo, MI 49007-3352
616·342·6326 Telephone/Fax

BARBARA WILDER

Late Autumn in the Poconas
Pastel, 19½x12½"

1902 Audubon Dr, Hanahan, SC 29406
803·569·2509

ENNIO ROMANO

Solitude Oil on canvas, 36x36"

via di Chianciano 25, 53047 Sarteano, Siena, Italy 0578·266·639 Telephone/Fax

KUEI-CHUAN WEN

Fly to Sky Oil on canvas, 24x48"
Books Oil on canvas, 30x40"

1501 Lincoln Way #402, San Francisco, CA 94122 415·664·7883 Telephone/Fax

MARCELLE HARWELL PACHNOWSKI

El Diablo y San Antonio Oil, 36x43"
Night into Dawn-Moorea Oil, 36x43"

222 Hicks St #2C, Brooklyn, NY 11201 718·858·6512

NORBERT H KOX

O Death Where Is Thy Sting: Yesu Christ the Fountain of Life Acrylic and oil on canvas, 96x48"
PO Box 109, New Franken, WI 54229 414·866·9187

· 80 · *Encyclopedia of Living Artists, 10th Edition*

OVIDIU LEBEJOARA
City of Angels Oil, 36x48"
3115 Montrose Ave #12, Glendale, CA 91214 818·541·0146

Encyclopedia of Living Artists, 10th Edition

BIRDELL ELIASON

Mexican Market Watercolor, 14x18"
Matador Oil, 24x20"

12 N Owen St, Mt Prospect, IL 60056 847·259·6166

· 82 · Encyclopedia of Living Artists, 10th Edition

RICHARDENE DYMOND
Valley Oaks Acrylic on canvas, 18x24"
890 Village Run Dr #102, Galt, CA 95632-2661 209·745·1732

LOIS HANNAH
Bear and Bull Bronze, 44x22x26"
21131 42nd Ave, Langley, BC Canada V3A 5A4 604·533·0150

GARIN BAKER
Crestview Summer Oil on linen, 26x58"
478 Union Ave, New Windsor, NY 12553 914·562·7802 Telephone/Fax

BILL BRACEY
Downtown Colored pencil and pastel on canvas, 24x36"
2923 23rd St S, Arlington, VA 22206-2501 703·920·3069 703·920·7826 Fax

· 84 · Encyclopedia of Living Artists, 10th Edition

FRANK TAIRA

Black Bridge Oil, 32x36"
Alone Oil, 20x18"

135 W 106th St #3Y, New York, NY 10025-3752

Encyclopedia of Living Artists, 10th Edition

PERLA FOX

Lily Pads, No. 2 Watercolor, 20½x28½"

12314 Moorpark St #203, Studio City, CA 91604 818·509·7763

MABEL MARTIN DAVIDSON

Peace Acrylic, 20x16"

Rt 2 Box 431, Three Links Rd, Mt Vernon, KY 40456
606·965·3123 606·986·4273 Fax

MARK GUDMUNDSEN

Grand Teton Fall Acrylic, 22x28"

51892 Quail Ridge Rd, Oakhurst, CA 93644 209·683·4308

Encyclopedia of Living Artists, 10th Edition

DOUG SCOTT

Happy Trails (Roy Rogers & Dale Evans) Colorado marble, Lifesize
Rt 1 Box 26, Taos, NM 87571-9500 505·758·4722

Encyclopedia of Living Artists, 10th Edition

DOUG SCOTT

Roy Rogers Colorado marble, Lifesize

Rt 1 Box 26, Taos, NM 87571-9500 505·758·4722

JOHN V PARTRIDGE

American Pride Watercolor, 20x27"
Where Liberty Abides Watercolor, 30x24"

PO Box 1893, Paso Robles, CA 93447 805·238·3393 805·238·4201 Fax

· 90 · Encyclopedia of Living Artists, 10th Edition

GRACE MERJANIAN

Tea Time Watercolor, 18½x24"
Light House Watercolor, 29x15"

18701 Deodar St, Fountain Valley, CA 92708 714·968·5983

Encyclopedia of Living Artists, 10th Edition

BILLIE BARTON

Expressions
Oil on canvas, 16x20"

High Country Bachelors
Oil on canvas, 36x36"

11720 E 207th St, Lakewood, CA 90715
310·865·5386

MARK PELNAR
Still Life with Drawings #1 Oil, 27¼x48"
4148 Vernon, Brookfield, IL 60513 708·485·6078

BETSY M KELLUM
Sculpture and Peaches on Mahogany Pastel, 24x18"
2808 Sugarberry Ln, Midlothian, VA 23113
804·897·0449

Encyclopedia of Living Artists, 10th Edition · 93 ·

RHONDA MCENROE

Spectrum Shadow Watercolor, 34x25"
Sheer Delight Watercolor, 30x20"

47837 24th St, Mattawan, MI 49071-9704
616·668·8281

· 94 · Encyclopedia of Living Artists, 10th Edition

DEMPSEY ESSICK

Early Spring at the Fritts Farm Watercolor, 13 3/4 x 19 1/2"
Roxie's Touch Watercolor, 17 x 25"

PO Box 1149, Welcome, NC 27374-1149 910·731·3499 910·731·3444 Fax

JOELA NITZBERG

Homeless Oil, 30x40"

16347 Royal Hills Dr, Encino, CA 91316 818·981·0410

JIAN-KANG JIN

Instinct of Love Oil on canvas, 78x78"

1693 Grove St, Ridgewood, NY 11385
718·628·1115 718·628·0358 Fax

Encyclopedia of Living Artists, 10th Edition

CHRISTIANE PAPE

Barcone Mixed media, 40x44 "
Arizona Acrylic on canvas, 34x30 "

500 E 77th St #907, New York, NY 10162-0014
212·472·9602 212·861·7324 Fax

Encyclopedia of Living Artists, 10th Edition

GILDA KOLKEY

Omnia Vanitas Oil on canvas, 24x48 "

1100 N Lake Shore Dr #21-B, Chicago, IL 60611-1017 312·787·3516

NOUZHA EVANS

Collective Mind
Oil on cardboard, 12x12 "

87 Elizabeth Wy
San Rafael, CA 94901
415·454·0895

· 98 · Encyclopedia of Living Artists, 10th Edition

RONALD BELANGER

Creation d'Une Planete Acrylic on canvas, 14x21"

PO Box 81, Stn F, Toronto, Ont Canada M4Y 2L4 516·535·9682
Represented by *Del Bello Galleries*, 788 King St W, Toronto, Ont, Canada M5V 1N6

ADRIENNE GILLESPIE

Pete's Harbor Oil, 16x20"

957 Matadero Ave, Palo Alto, CA 94306 415·856·9580 415·856·6024 Fax

R M SUSSEX

Morning Paper Oil, 16x20"

2005 S Fairway Dr, Pocatello, ID 83201 208·237·3396 208·232·2178

· 100 · Encyclopedia of Living Artists, 10th Edition

LOU GRAWCOCK
Fun Guys Pastel drawing, 18x24"
5971 S Woodstrail Dr #57, Columbia City, IN 46725-9418 219·691·2610

HELI HOFMANN

Summer Oil on canvas, 36x36"
Beautiful Bavaria Oil on canvas, 36x36"

5870 Cactus Way, La Jolla, CA 92037-7069
619·459·4610 619·459·1754 Fax

ANDREW ANNENBERG

Balance of Nature Oil on linen, 24x18"

PO Box 778, Kula, HI 96790-0778 808·878·3010 808·878·1662 Fax

Encyclopedia of Living Artists, 10th Edition

GHAMBARO CHEUNG

In the Garden Oil, 24x30"
Mother and Children Oil, 30x40"

3620 168th St #5A, Flushing, NY 11358-2143 718·359·1589 Telephone/Fax
Reprented by *IPCC*, 20-22 130th St, College Point, NY 11356 718·460·2787

CRYSTAL MOLL

Springs' Green 1996 Oil on canvas, 41x20 "

217 Mariners Point Dr, Baltimore, MD 21220 410·391·3166 410·837·3621 Fax

Encyclopedia of Living Artists, 10th Edition

NAGI CHAMI

Turkish Bath Oil on canvas, 68x99 "

PO Box 331, Los Altos, CA 94023-0331 415·949·1561 415·961·1287 Fax

FRANCES MIDDENDORF

The Beach Gouache and ink, 6x17"

337 E 22nd St #2, New York, NY 10010
212·473·3586 Telephone/Fax
Represented by *Silverwood Gallery*
24927 Vashon Hwy SW, Burton, WA 98013
800·536·8287 206·463·1722

JAMES ELLISON

Pilgrim Oil, 24x48"

2907 Blakeman Ave, Rowland Heights, CA 91748-4812 818·965·8184

Encyclopedia of Living Artists, 10th Edition

Ayona's Birth by Darcy Dziedzic

JAMES EUGENE ALBERT

10 *Hard Boiled*
Iris ink on 100% rag paper, 20x28 ". Artist's collection.

11 *Strange Yellow Room*
Iris ink on 100% rag paper, 24x24 ". Artist's collection.

140 *Comet*
Iris ink on 100% rag paper, 18x13 ". Artist's collection.

James Eugene Albert started painting with acrylics as recreation in the mid-sixties. He finally found the ideal palette in the computer and 'digital' paint. "If traditional painting could be compared to classical music then 'digital' painting can be compared to jazz. One can be spontaneous, flexible and improvise colors and textures on the fly."

The images presented here represent new work from his seventh book of digital paintings entitled *The Strange Yellow Room*. Discovering this medium of computers over the last ten years has liberated Albert's creative energies. His style has been significantly expanded and transformed. It has also lit a fire and passion within him to continue to strive to create the most fantastic, outrageous images imagined. Acceptance of digital painting as a serious fine art form has come quickly.

Each of his images is available in limited edition of twenty-five iris proof prints on 100% rag paper.

Price range of original work: $1000 - $2000.

Represented by *Gemini Productions*, 601 Van Ness Ave #E3518, San Francisco, CA 94102-3200 415·776·6632
415·776·6761 Fax http://www.cdiart.com/albert

LUCIANA AMIRGHOLI

49 *A Portrait of Love*
Acrylic, 48x40 ". Artist's collection.

Luciana Amirgholi holds a BFA from York University, in Toronto, Canada. She has received several awards for her vibrant paintings and has been featured in various publications including *Manhattan Arts International*.

She has worked as a visual art instructor and was instrumental in cofounding the Arts Program for Children at the Irving Arts Centre in Texas.

Her series of paintings explore the drama of life, enticing the viewer into a world of heightened color, emotional expression and the inner depths of human behavior. Her subject matter is the human figure rendered in a representational manner, derived solely from her imagination and her encounters with people. She quotes, "It is the character of the subject which intrigues me, not their identity."

Her paintings reveal a passion for bold pure complimentary colors, inspired by the Fauve period. The intensity of her palette translates to the powerful, emotional expression of her subjects and the overall mood of her paintings. Amirgholi states "My paintings are a play on life, a world that evokes passion and intrigue, and the acknowledgment that within the drama of life lies.....a mystery." She has exhibited in galleries and public spaces nationally and continues to attract prestigious private collectors.

Price range of original work: $1000 - $5000.

3012 Silver Spring Ln, Richardson, TX 75082 214·994·0973
214·488·0200 Fax http://www.OnLineGallery.com

MICHELLE ANGERS

129 *Red Sky*
Waterbased dyes and colored pencil, 13 ½x22½".
Artist's collection.

Michelle Angers is a self-taught artist. Her love of art began during childhood drawing horses. Over the years, she has refined her styles, putting emphasis on the decorative aspect of her paintings. Using bright, rich colors and bold shapes and lines, her works are whimsical but not timid. She specializes in animal themes as animals are her other passion.

Angers has donated images for use in the Windsor/Essex County Big Brothers/Big Sisters Calendars for 1993 and 1994. She is displaying her work at the Windsor Cat Care Society. Her career as a professional artist began in May 1995. She is most interested in creating artwork for greeting cards, prints, posters, calendars, children's books, etc. To date she has met with much favorable response. She is currently working on private commissions and illustrations for two children's books.

Price range of original work: $1000 - $5000.

2453 Olive Ct, Windsor, Ontario Canada N8T 3N4
519·948·7853

ANDREW ANNENBERG

103 *Balance of Nature*
Oil on linen, 24x18 ". Private collection.

Andrew Annenberg is recognized as one of today's foremost visionary artists, acclaimed for his meticulous detail, imagination and wit.

Annenberg frequently visited the nation's prime repositories of art treasures: The Smithsonian Institute, the National Museum of Art and the Natural Museum of History.

He recalls his early years: "I was always drawing or painting. Everything else was something I had to do so I could return to my art."

Themes from ancient Egypt, classical Greece and England and the lost civilizations of Atlantis and Lemuria are powerful focal points in much of his work. He turns our minds within to the fantastic

realms where consciousness is undefined, bringing us to a meditation on that which lies beyond.

Annenberg is interested in what he calls 'the environment of the mind.' He believes that his provocative paintings move people to ponder their surroundings by making the viewer aware of the his own participation in the rise and fall of civilizations.

The primal, the Archetypal, the mythological, the ancient—it is their timelessness and the enduring nature of the spirit that Annenberg captures with his art.

Price range of original work: $5000 - $95,000.

PO Box 778, Kula, HI 96790-0778 808·878·3010
808·878·1662 Fax E-mail: andyart@maui.net

CHRIS APOSTLE

20 *Towards a New World Order*
 Oil, 48x68". Private collection.

20 *Valentine Masquerade*
 Oil on canvas 48x68". Private collection.

Child prodigy in art, Chris Apostle stopped painting until he was 60 years old. At that age he painted 300 paintings and over 1500 outlines for paintings-to-be. Listed in *Who's Who in Science and Business*, he has published academic papers in sociology, economics and philosophy. A real estate developer, college professor, inventor and published poet, he expects to live to be 108 years old.

He has developed an artistic concept: "situational chromatic symbolism" which demands emphasis on color and its juxtapositions. This interest developed in the 1950s when Apostle was a architectural student where he painted color sticks on white walls and eventually started to place images on these rectangular canvases. Because of the diversity of his artistic styles, he is often called the "Picasso of the Hudson" by his peers.

Price range of original work: $600 - $55,000.

PO Box 557, Newtonville, NY 12128-0557 518·462·5113
518·785·5673 Fax

ERNIE APPLEWHITE

12 *Envision*
 Computer, 11x14". Artist's collection.

As a native of Pascagoula, MS, Ernie Applewhite enjoyed the rich natural environment of the Mississippi Gulf Coast as a child.

He was introduced to computers in 1986 through computer aided design. His interest began to evolve into 3D and animation. Applewhite, influenced by his native surroundings, paints sailboats, lighthouses, wading birds, sea life and shrimp boats. Using more than 16.7 million colors, the computer has enabled him to create a multitude of visual designs and effects. "The capability of combining real life with surrealism keeps the creative wheels turning."

9612 Ferry Point Rd, Gautier, MS 39553-1924 601·497·1290
601·762·4173 Fax E-mail: FYEL03A@Prodigy.com

GARIN BAKER

84 *Crestview Summer*
 Oil on linen, 26x58". Artist's collection.

Born and raised in New York City, Garin Baker received his BFA from Pratt Institute. He also studied at the Art Student League in New York City. Presently he teaches a life painting class at the School of Visual Arts. He has won numerous awards and actively exhibits his work in New York City and the Hudson Valley region. Baker's work is traditional in its approach. Working primarily from life and on the spot studies, he tries to capture a moment in time. His subject matter varies from large New York Cityscapes filled with bustling people set in dramatic light situations to spacious rural landscapes reminiscent of the Hudson Valley River School of Painting. At the core of Baker's work is a strong sense of people and their relationship to the environment. "No need to shock or over intellectualize when simple human emotions, communicated visually, can bring us to a place where we can all share our common experiences." In the painting *Crestview Summer*, we're a child at play with our friends. There are no complications, fun and joy is the agenda.

Price range of original work: $4500.

478 Union Ave, New Windsor, NY 12553
914·562·7802 Telephone/Fax E-mail: irej@ny.frontiercomm.net

MIGUEL BARBOSA

38 *Face of Tragedy*
 Acrylic, 35x24". Artist's collection.

Miguel Barbosa has an equal number of noble titles and international awards, the latter from important museum shows and biennials. He exhibits in France and Portugal and is one of Portugal's most successful artists, as well as one of the best in Europe.

Photographs and critiques of his works are included in the best art anthologies: *L'Officiel des Arts* (Paris), *La Coté des Arts* (Marseille), *Who's Who International* (Lausanne), and *Men of Achievement* (England). His art reflects what's happening in Lisbon, Europe, Brazil and the United States. He has an acute vision of both spiritual and materialistic influences around the world. A successful paleontologist, writer, theater writer and poet, he has received important awards in many diverse areas. He creates strong figures that are sometimes distorted, to interpret his moods, his thoughts and his emotions.

Ave Joao Cristostomo 91-2 Lisbon 1050 Portugal
00351·314·0793
Represented by *Abney Gallery*, 591 Broadway, New York, NY
10012 212·941·8602

BILLIE BARTON

92 *Expressions*
 Oil on canvas, 16x20". Artist's collection.

92 *High Country Bachelors*
 Oil on canvas, 36x36". Artist's collection.

Billie Barton is a southern California artist and instructor. Presently she teaches private classes at her studio. She devotes her non-teaching time to painting. She participates in invitational and juried exhibits, regionally and nationally. She has exhibited four

times with the Fine Arts Institute at the San Bernardino County Museum, at the Santa Barbara Museum of Natural History, at the Arts Associates Gallery of Huntington Beach, and at the La Mirada Art Gallery in La Mirada, California. She has also exhibited at an invitational art exhibit with the Fine Art Institute of Boston. Her artwork was published in the third edition of *Artists of California*. She has authored a book entitled *The Guidebook for Oil Painters*. Her works hang in private collections in the United States, Canada and Korea.

Price range of original work: $350 - $3500.

11720 E 207th St, Lakewood, CA 90715 310·865·5386

BATES

64 *Cuttings*
 Oil, 44x20".

65 *Testing*
 Oil 44x34".

Born in 1962, Bates was raised in Aspen, Colorado, the daughter of a writer/photographer and a silver/goldsmith. She is essentially a self-taught painter.

"Although I had a lot of community arts training as a child, I succumbed to art later in life. When I was a young woman I had serious reservations about a career as a painter, opting instead for artistically-related fields, at which I was good but not brilliant. Every path I pursued eventually led me back to fine art, in particular, figurative realism. Eventually I had to face up to the fact that I was avoiding art. Not long after that...conditions in my life abruptly changed, and I was forced to make a choice."

At age thirty, Bates began painting. Her first original oil won a significant regional purchase award, and five pieces from her first eighteen months of work were selected for nationally juried shows and awards. Since then her work has continued to receive widespread national attention. Bates' subject matter is primarily figurative, her style impressionistic realism, use of light is often a central theme.

Price range of original work: $400 - $4500.

PO Box 1405, Basalt, CO 81621 970·927·9363

FRAN BEALLOR

63 *The Date*
 Oil on canvas, 48x30". Artist's collection.

"Fran Beallor's complex, impeccably painted portraits, still-lifes and interiors are the work of an artist who knew from an early age that she wanted to be a classically trained realist painter." Eunice Agar, author of Mirror Images: the Work of Fran Bealler, *American Artist Magazine*, 11/94

Throughout the last twenty years, Beallor has shown her contemporary style of realism in numerous solo and group exhibitions across the U.S. and Canada. She has shown with the Sherry French and Grand Central Art Galleries in New York City and at the Hudson River Museum, in New York and the Springville Museum, in Utah, among others.

Her honors include grants from Artists' Space, the Greenshields Foundation and the New Jersey State Council for the Arts. Her paintings have been chosen for the covers of *Manhattan Arts International* and *Art Calendar* magazines. Beallor's artwork graces the walls of many corporate, private and public spaces around the U.S.

A full-color 28-page brochure prepared for a recent museum show is available upon request.

Price range of original work: $500 - $30,000.

839 W End Ave #6F, New York, NY 10025 212·864·7465
212·932·0151 Fax E-mail: 73002.1247@compuserve.com

RONALD BELANGER

99 *Creation d'Une Planete*
 Acrylic on canvas, 14x21".

Ron Belanger is a graduate of Ontario College of Art in Canada. Belanger's painting can be seen as a microscopic world of light and energy, or as vast galaxies of pulsating power, an astronomical garden growing in a silent sky.

His paintings can be found in Canada, U.S., Mexico, Argentina, Spain, England, France, Italy and Germany. In 1993 he won the Médaille D'Or, Mérite et Dévouement Francais, in Paris. In 1992 he won Médaille D'Or, Grand Prix du Soleil Levant and Biennale de Lutèce, both in Paris, as well as Médaillon D'Argent, Grand Prix Mondial D'Art des Ameriques in Paris.

Price range of original work: $7 sq inch.

PO Box 81, Stn F, Toronto, Ont Canada M4Y 2L4 516·535·9682
Represented by *Del Bello Galleries*, 788 King St W, Toronto, Ont, Canada M5V 1N6

BRUCE BENNETT

56 *Today's Israelis Jerusalem Israel 1991 #2*
 Ektacolor photography, 6x6".

Bruce Bennett received his BFA from the Rochester Institute of Technology in 1987. Since 1989 he has been in 150 solo and group shows. His work has been acquired by 100 leading museums and collectors, such as the Museum of Modern Art, Metropolitan Museum of Modern Art and Smithsonian's National Museum of American Art.

He has developed a series of photographs showing the simple, yet inwardly powerful lives of people in the economically drained community of Appalachia, Virginia and another series of the daily struggles of migrant families in poverty-stricken Indiantown, FL.

"I try to make empathy the hallmark of my photography. I use my camera to unveil an innate dignity in people, and strive to picture how they relate to themselves and others."

He has now embarked on a long term photographic book documenting the exploration of Israel's changing identity. "Today's Israelis—A Country in Transition offers my deep appreciation for the history and circumstances surrounding ancient cultures. Now, after centuries of exodus, they're coming home. This is one of the greatest social movements of our time."

Price range of original work: $385 - $1250.

1624 Monroe Ave, Rochester, NY 14618-1417 716·271·5052
716·271·2956 Fax

ORNA BENSHOSHAN

47 *All for One*
 Oil on canvas, 36x36".
47 *Peachy Dandy*
 Oil on canvas, 40x30".

Orna Benshoshan arrived in the U.S. in 1982 from Israel, where she grew up on a kibbutz. Her distinct artistic style, characterized by its detailed execution, often infuses the human experience with subtle humor. Critics remark that each of Benshoshan's pieces is a world unto itself.

Having received her training as a graphic designer in Tel Aviv, she is presently working on a rapidly growing collection of oil paintings. Her early mixed-media paintings and serigraphs reflected social phenomenon. More and more her commitment to holistic healing nourishes the spiritual values reflected in her recent art. Much of her work is driven by the goal to transform mystical and spiritual ideas into a contemporary visual form.

Benshoshan has exhibited her work in museums and galleries around the country and abroad and has won several awards. Her work has appeared as editorial illustration in *Yoga Journal* and *Recycled Paper Products*.

Price range of original work: $800 - $4000.

7 Hamaapilim St, Ramat Hasharon, Israel
011·9723·549·7514
Represented by *Donna Davis*, 100 Golden Isles Dr #807, Hallandale, FL 33009 954·456·2370

CAROL BERNARD

135 *Les Baux*
 Acrylic on paper, 44x34". Private collection.

Carol Bernard has a BFA from the School of the Art Institute of Chicago and an MFA from the University of Southern California in Los Angeles. When working with landscapes, she uses photographs she takes of possible compositions she sees when traveling, either in her vicinity or elsewhere in the U.S. and abroad. She works in an Abstract Impressionist manner in which her subject matter is clearly recognizable. She has shown in galleries in New York City, Chicago, Los Angeles and Mendocino as well as her hometown, Davis, California. She has received numerous awards, purchase prizes and honorable mentions. She is a member of Women Painters West and a signature member of the National Watercolor Society. *Les Baux* was completed in a town of the same name near Arles, in Provence, France.

Price range of original work: $800 - $2500.

1921 Imperial Ave, Davis, CA 95616-3164 916·757·7731

ROBERT G BERTONE

Front cover *Metal Man*
 Oil on linen, 68x44". Artist's collection.

Robert G Bertone, primarily a self-taught artist, has had numerous group and solo exhibitions in New Jersey, New York and Paris. His work also appears in many private collections.

Bright colors have enlivened Bertone's oil paintings from a very early age. His images are born from an internal sense of shape and form. These forms grew, expressing themselves as space aliens, human landscapes and dreaming nudes. Bertone states, "My ideas are only bound by my imagination, which seems to have a mind of it's own."

Bertone has taken great care in preparing his canvases in the traditional classical approach. The canvases are hand stretched, rabbit skin glued, and oil primed in the same manner as the old masters. He works primarily on large linen canvases and panels, but recently began hand-pulling silk screen prints. Bertone says, "I think that serigraphs are a wonderful expression for my art. They allow me to further explore my compositions and ideas that I may not have with painting alone."

Price range of original work: $1200 - $2400.

589 61st St, West New York, NJ 07093 201·868·8392
201·868·1444 Fax E-mail: rbertone@mail.idt.net

BILL BRACEY

84 *Downtown*
 Colored pencil and pastel on canvas, 24x36".
 Artist's collection.

Bill Bracey has a BA in art from Hampton University in Hampton, Virginia. After graduation, he obtained a law degree from Howard University's Law School. He has held positions in government and industry, yet never has lost his passion for art. His artistic instincts and drives were ever-present and manifested themselves in painting and photography as vocations.

In 1994, Bracey decided to pursue a full-time career as a professional artist. He has exhibited locally and nationally. He is a realist and strives to create images that are measured and technically accurate in terms of subject matter and structure. His primary goal is to produce works that have impact in conveying emotion and mood. He does this through manipulation of light, color, contrast,

Gray Area by Renee M^cGinnis

space and form to achieve works characterized by high detail and clear definition.

For him the depiction of reality is the expression of truth. It excites him to see the evolution of a painting: to him it is the evolution of truth. He wants to recreate what he sees in humanity and nature with positive images and bold statements of truth.

Price range of original work: $800 - $2500.

2923 23rd St S, Arlington, VA 22206-2501 703·920·3069
703·920·7826 Fax E-mail: wbracey@capaccess.org

JENNETTE BRICE

59 *Hilton Head Beach*
 Acrylic, 24x30". Artist's collection.
59 *Roof Tops*
 Acrylic, 34x24". Artist's collection.

Jennette Brice has been painting and designing products since 1980 when she graduated from the University of South Carolina with a BFA in Art Education.

She has painted furniture with her art that is shipped worldwide. Much of her work has been privately commissioned mural installations.

Brice has had several solo exhibits, exhibiting nationally, including the prestigious National Society of Painters in Casein and Acrylic in New York.

She is a signed artist to be published by Gango Poster Publishers in Portland, Oregon. Artist-enhanced limited edition canvas reproductions are available.

Price range of original work: $1000 - $2500.

4301 La Vera St, High Point, NC 27265 910·454·1363
Represented by *Hargis Unique Gallery* 909·623·8977

ERIK BRIGHT

130 *Universe in a Pot*
 Ceramic, 17½". Private collection.

Erik Bright received his BFA from Rhode Island School of Design. The sources for his work come from a combination of life experiences and dreams that recognize the depth and power of childhood and the degree to which it has influenced his art. Though Bright has travelled and lived in many places, it is both his Norwegian heritage and having spent 14 years in Africa that have proven to be most compelling in his work. From these contrasting cultures, he has gained both an appreciation of pattern as language, symbol and movement, and a sensitivity to the portrayal of stories told on functional forms. The pieces are thrown on the wheel in a white stoneware or porcelain clay. They are then painted with a black slip and carved in the sgraffito technique. These materials provide not only clear imagery and patterns as a result of their contrast in value, but also create a relief effect that literally brings the drawings forward into the viewers space. The sharp quality of line achieved in the carving process complements the power of the images "The stories I tell are sagas that come from the conscious, unconscious and subliminal space between."

Price range of original work: $150 - $900.

54 Trenton St, Providence, RI 02906 401·861·8196
401·521·0378 Telephone/Fax

KURT C BURMANN

70 *Pinnacle Peak Planetary Vista*
 Acrylic on canvas, 36x48". Private collection.

Kurt C Burmann is one of the most renowned and admired space and visionary artists, known for his exquisite use of color, with attention to detail and perspective. His unique blend of visionary, environmental and space art themes, combined with a metaphysical and spiritual flare, have earned him many top awards and international acclaim.

He has illustrated greeting cards, posters and fine art prints as well as the covers and pages of many leading magazines and books including: *In the Stream of Stars,* V*isions of Space* and Isaac Asimov's *Library of the Universe.*

He has produced large murals for science centers and space museums. Burmann's originals have been displayed in prominent museums, including the Smithsonian National Air and Space Museum.

He has exhibited internationally as well as throughout the U.S. including: 'The IAAA-ASTC Other Worlds' and prestigious 'USSR Dialogues,' held in three major cities throughout Russia.

Price range of original work: $20,000 - $165,000.

7127 E Becker Ln #2001, Scottsdale, AZ 85254 602·483·1530
602·596·3471 Fax

NAGI CHAMI

106 *Turkish Bath*
 Oil on canvas, 68x99". Private collection.

1992-1994	Weinstein Gallery, San Francisco, CA
1992	Gallery 555, San Francisco, CA Solo exhibit
1990-1992	Forster Collection Gallery, San Francisco, CA
1990	Gallerie Farouche, Paris, France
1989	Academy of Art College, San Francisco, CA Solo exhibit
1987-1989	Academy of Art College, San Francisco, CA
1986	Gaeity Gallery, Dublin, Ireland Solo exhibit
1986	Galeria 57, Madrid, Spain
1985	Gallery Reynolds, London, UK
1984-1985	Redec Plaza Gallery, Saudi Arabia Solo exhibit
1979-1985	Palais de L'Enesco, Beirut, Lebanon
1984	Galleria Trentadue, Milano, Italy

"I paint people how I see them. I look beyond the physical shell and remove the facade releasing the pain and enslavement of life, releasing the brutality towards ones self and to each other. Transcending all barriers and reaching through the universal language of passion. My subjects are stripped of their masks, open and vulnerable. Unleashing faces they don't wish to be seen; sans age, sans gender, sans language. Raw, unpolished faces."

Price range of original work: $8500 - $38,000.

PO Box 331, Los Altos, CA 94023-0331 415·964·7119
415·964·7111 Fax

HUMBERTO CHAU

24 *Morning in a Bali Hamlet*
 Oil, 38x46". Private collection.

Humberto Chau, born in Peru, went to China for his education. His works have been exhibited both in Peru and the U.S. He

Primary Crossing by Veronica Galati

participated in the 1992 ArtExpo in New York with the theme of "The Glamour of the Orient," which captured the native, colorful, and tropical flavors of East Asia, and elicited a warm reception and rave reviews.

He was selected to have a solo exhibit at the 1992-1993 Individual Artist Showcase Competition, sponsored by Queens Library and the Alliance of Queens Artists in New York City. He received an Award of Merit at the 1992-1993 Alliance of Queens Artist Annual Juried Exhibit. In 1993 he held a solo exhibit at Arts World, New York City and Amerasia Bank, Flushing, NY.

His works have been published in *Artists of Chinese Origins in North America Directory, Album of Works by Overseas Chinese Artists, Foreign Artists of Chinese Origin, Dictionary of the Achievements of World Chinese Artists,* and *The Encyclopedia of the World Famous Chinese Artists.*

42-11 149th Pl, Flushing, NY 11355 718·539·2522

GHAMBARO CHEUNG

104 *In the Garden*
 Oil, 24x30". Artist's collection.

104 *Mother and Children*
 Oil, 30x40". Artist's collection.

Ghambaro Cheung was born in Guangdong, China in 1948. He moved to Hong Kong with his family the next year.

Cheung displayed an early interest in art and won several youth art contest in Hong Kong. He decided to further refine his artistic talents and skills at Guangzhou Academy of Fine Arts and Jinan University in China. After graduation, Ghambaro traveled extensively in Europe. In 1977, he was invited to New Zealand to teach and paint. New Zealand television broadcast a series of programs featuring his techniques of Impressionistic style painting. During the spring of 1986, he settled in the U.S. and continues to contribute to the artworld.

When Cheung paints a landscape, he creates a good relationship between human and nature. The human form in the composition becomes part of the landscape.

Cheung's works have been exhibited in the Chinese Art Exhibition, Beijing, China; Guangxi Art Exhibition, Naning, China; Widdicombe Art Fair, New Zealand; Aaron Gallery, USA. Recent exhibitions include New York Art Expo '96 and Art show at Center for International Art Culture in New York.

Price range of original work: $2500 - $3500.

3620 168th St #5A, Flushing, NY 11358-2143
718·359·1589 Telephone/Fax
Represented by *IPCC*, 20-22 130th St, College Point, NY 11356
718·460·2787

ALEX CHUBOTIN

118 *Untitled*
 Bronze, 10x5x3". Artist's collection.

Alex Chubotin received his MFA from the Kiev National Art Institute, Ukraine, in 1987. He emigrated from Ukraine in 1993, seeking intellectual and artistic freedom. With his classical training, he works chiefly in sculpture, but also in various drawing media. As a sculptor, he is equally comfortable working in small- and miniature-scale, as well as monumental pieces. His largest monumental work was five life-size busts sculpted in clay.

Chubotin finds the inspiration for his work most often in religious themes. Drawing from archeology and anthropology, combining historical with spiritual themes, he tries to create an awareness of the chronological and geographical universality of our religious and spiritual consciousness.

Three cycles—The Apocalypse, The Great Migration of Peoples and The Adoration of the Magi—represent his range. His works focus on a need for a deeper awareness of our intellectual heritage and its significance in our lives.

1720 E Denny WY #203, Seattle, WA 98122-2705 206·322·5908

JEFF CHUN

139 *The Zen Kiss*
 Oil, 20x20". Artist's collection.

Jeff Chun graduated in 1984 from California State University at Long Beach with a Bachelors Degree in Fine Arts.

In 1985 he was commissioned by the White Mountain Apache Tribe to paint two portraits for their Cultural Center in Fort Apache, Arizona.

From 1987 to 1991 Chun worked on a series of paintings and drawings devoted to figure skaters. Enamored by the dance-like beauty of the skater, he found that the athletes resembled performance artists.

Currently his varied interests coupled with the constant bombardment of stimuli in this modern world have influenced him to paint a multitude of diverse themes, including a small set based on bonsai plants, a modest group of mini-canvases that deal with social-political satire, plus a series based on a personal psychological study into mysticism. In the future he plans to do a

collection based on mythological warriors of different cultures.
Price range of original work: $700 - $900.
4107 W 177th St, Torrance, CA 90504-3628 310·793·0290

JUDITA ZILIUS CLOW

44 *Blossom*
 Watercolor, 14x17".
 Artist's collection.

44 *Reflections*
 Watercolor, 14x17".
 Artist's collection.

Judita Zilius Clow has been drawing and painting since her childhood in Lithuania. Throughout the years she has worked in pencil, pen and ink, charcoal, oils, pastels, and watercolors—her main interest was portraits and fashion illustration. In the last few years, as her interest in the interplay of color, light and form has deepened, her focus has shifted from the realistic to the semi-abstract. Since then she has been painting on nonabsorbent paper, a technique that enables her to explore the beauty and versatility of watercolors.

Clow studied portraiture at the art school of the Brooklyn Museum of Art under Isaac Sawyer and at the Art Students League in New York City under Olinsky. She studied fashion illustration at the Parson's School of Design.

Her work has been shown at group and solo exhibits in New York, North Carolina and Vermont. Recently her paintings were displayed at a three-month solo exhibition at Trinity College in Burlington, VT. Last spring she was selected to attend the Vermont Artists' Week at the Vermont Studio Center in Johnson, VT.

4 Clayton St, St Johnsbury, VT 05819 802·748·5299
802·748·8324 802·748·4394 Fax
E-mail: clow@plainfield.bypass.com

JULIE KRAMER COLE

54 *Circle of the Sacred Dogs*
 Pastel, 17¼x21½". Private collection.

Julie Kramer Cole is celebrating her tenth anniversary in the limited edition print market. In 1986, she published her first limited edition print, *Man Who Sees Far*, which was sold at art shows for $35. Their retail price now is $3500+. From that beginning she has published thirty limited edition prints.

She has the unprecedented accomplishment of being the first woman artist to have three prints selected in the top twenty-five prints for one year.

Cole attended Colorado State University, with a major in art, graduating from the Colorado Institute of Art. She spent 15 years as a commercial artist in Denver. In 1980 she was inspired to enter the fine art field where she developed her unique style of visually telling a story with a painting.

"Emerging image art creates an ongoing experience that pulls the viewer into the painting. Using this genre, I can best portray the relationship of man, land and animal. Native American art is rich in history. My version of this art depicts a short span of a colorful

Day Dream by Zhaoming Wu

past and the spirituality of this past is credible today."
Price range of original work: $8000 - $15,000.
PO Box 7268, Loveland, CO 80537-0268 970·663·6201
970·663·6485 Fax

JACK D COWAN

32 *Breakfast in Bed*
 Oil on canvas, 31½x36½".
 Private collection.

Jack D Cowan is a native Floridian. His work has been represented in Chicago, featured in Los Angeles, and exhibited numerous times at the prestigious Hoosier Salon in Indianapolis. Current representation includes Sarasota, Boca Raton and Miami, Florida.

He says "Art is about the artist. Individuality results from personal experience and unique creative expression. A large part of my individuality is the development of a distinctive style and point of view. My goal is to portray all things beautifully, even the tragic." The human figure is a constant throughout his body of work. He points out, "I rarely paint a faceless figure. The face reveals individuality and the eyes are the windows of the soul."

Whether depicting the mythical, symbolic or classical, he seeks to reconcile a contemporary sensibility with universal themes. At present, Cowan continues to produce new works, including commissions, and maintains a clientele of private and corporate collectors.

Price range of original work: $6000 - $22,000.
502 E Anderson St, Orlando, FL 32801 407·426·8291

IVO DAVID

34 *First Steps*
 Oil on canvas, 30x24". Private collection.

Ivo David is, without question, one of the most original and resourceful modern artists of our time. David was born in Europe where he completed his academic curriculum in the arts and philosophy. He was invited to have a solo show in New York in 1962 at the Crespi Gallery.

David was an apprentice at this father's art atelier and worked with prominent European artists. For many years he continued in the style of his father, Arduino, also a well-known artist.

He is the founder of the artistic art movement "The Fusionism," originated by him in Europe in 1956. His original Manifesto of the Fusionism is registered with the Library of Congress in Washington, DC.

David's fusionistic art is: "....impulsive color that mingles itself with powerful results and which constitute the synthesis of the spirit with the matter, the dream with the reality..." Prof. NhM Alemanno, President of the Intl Academy of Fine Arts of the Micenei.

Price range of original work: $6000 - $25,000.
2027 High St, Union, NJ 07083-3814 908·964·5660
908·686·0288 908·688·0490 Fax

MABEL MARTIN DAVIDSON

86 *Peace*
Acrylic, 20x16". Private collection.

Mabel Martin Davidson lives on a farm nearby her childhood home. It was here, where both her paternal and maternal ancestors lived since before the civil war, that her love for art took root. "I am grateful for a heritage that has kept alive an appreciation for art, music and nature."

Peace is part of the private collection of John and Faith Jones of Ohio. "*Peace* is the kind of place where I could sit under a tree for hours enjoying the calm atmosphere as the birds and animals watch over their young. Such quiet times with God amid the beauty of his wondrous creations never fail to refresh my soul and inspire me to paint. If my work brings a smile or a bit of enjoyment to its viewers my goal has been accomplished."

"Peace I leave with you, my peace I give unto you: not as the world giveth, give I unto you. Let not your heart be troubled, neither let it be afraid." John 14:27

Rt 2 Box 431, Three Links Rd, Mt Vernon, KY 40456
606·965·3123 606·986·4273 Fax

JANET DELFOSSE

51 *Pink Sky*
Pastel, 14x17". Artist's collection

Janet Delfosse is a self-trained artist. She has spent five years in an intensive study of color, light, shape, composition and perspective through extensive reading, observing and creating.

She has had her works exhibited at many shows around the country and has appeared in *Manhattan Arts International* magazine. Her works are in private collections overseas and in the U.S. Her work is mainly of her own imaginings, relying heavily on her perception of the world. Expressing herself through art has opened up new horizons of personal understanding, and she now views herself, her family and the world around her with a new clarity. Many of her pastels depict still lifes, landscapes, human relationships, or abstract colors and shapes. Delfosse uses pastels to express the beauty and fragility of nature and relationships. The vibrancy and purity of pastel colors enable an expression of landscapes and emotions unattainable with other mediums.

Price range of original work: $450 - $800.
10696 Graeloch Rd, Laurel, MD 20723-1188 301·490·5742

NANCY DELGADO

17 *A Little Worse for Wear*
Watercolor, 12x19". Private collection.

Nancy Delgado loves to paint people caught in the act of doing activities they love. Her work almost always contains people interacting with their environment or each other.

Delgado's art is much more than colored marks on paper or an organization of contrasts, it is a reflection of heart and soul. Through layer upon layer of transparent watercolor, she carves out a celebration of life portrayed in the look of wonder on the face of a child, the passion a musician feels for her music, or the long parade of memories behind the eyes of an old man.

Having been given a natural talent and little formal education, Delgado has learned to use watercolor by extensive reading of other artists techniques and by her own experimentation. She has works in numerous private collections across the country and is actively showing her work locally and in national juried competitions.

Price range of original work: $600 - $3000.
PO Box 471, Forks, WA 98331 360·374·6885

B DOUGLAS DEWAR

71 *The Weigh In*
Prismacolor pencil, 23x29". Artist's collection.

B Douglas Dewar is a native of Bedford, England, where he learned the art of colored pencil as a young schoolboy. Self-trained, he has rejuvenated an interest in colored pencil art, which involves a distinctive fine-detailed style. He achieves his technique by applying many thick layers of pencil, to which he applies a method called sgraffito, combined with burnishing. His style, which has become highly recognizable, surprises art lovers once they discover it is colored pencil. His work has been arousing the attention of animal lovers as well as others around the country and overseas. Dewar has been donating his artwork to silent auctions for animal causes for several years. Owners of the animals he has been commissioned to draw are pleased to see he has captured that 'certain look' that only the owners know so well. His art is in private collections from California to Bermuda.

Price range of original work: $800 - $3500.
2860 Peninsula Rd #900, Oxnard, CA 93035-4040 805·984·8080

SHU-TANG DONG

66 *Boats*
Acrylic on paper, 16x20".

Shu-Tang Dong is from Taiwan. He has spent his entire life teaching and painting. In 1976 he had the honor of representing Taiwan, The Republic of China, participating in the World's Educators' Conference, held in Hawaii. He demonstrated and lectured Chinese brush painting in front of 300 delegates from 25 countries.

In addition to his 22 years experience with traditional Chinese brush painting, he has earned his BFA from San Francisco Art Institute, as well as a MA from California College of Arts and Crafts. His work has been collected by the Historical Museum in Taiwan, Asian Art Museum in San Francisco, and numerous private collectors around the world. He is currently represented by Art Circle in Benicia, Valley Art Gallery in Walnut Creek, and Shepherd Art Gallery in Danville, California.

Price range of original work: $300 - $6000.
2473 Casa Wy, Walnut Creek, CA 94596
510·937·9292 Telephone/Fax

DONNA DUGUAY

73 *Maison pour Deux #8*
Oil pastel and mixed media, 29x41". Private collection.

Since Donna Duguay graduated from UC Berkeley in 1982, her subject has evolved from the figure to narrative landscapes in which images of houses express more about feelings than literal architecture. She affirms her psychological realization through

Jung's theory that the house can be a symbol of the self, both in dreams and in the creative process; thus, her inspiration comes from actual places and events combined with fantasy. Ideas of home changed as she adapted to numerous moves throughout her childhood, and continue to be ever-changing within her live/work environment as an artist. Using an array of personal and archetypal symbols, she relates a direct concern with individual needs for privacy in general, as well as a retreat from disturbing elements in one's environment; conversely, a space can sometimes seem to imprison the physical/spiritual self.

Duguay has developed her own techniques in using oil pastels in an additive/subtractive process over textured black gesso, combining exaggerated colors in seemingly peculiar juxtaposition and distorting perspective. One's senses are virtually confronted with multitudinous color/texture, and content, simultaneously projecting abundant metaphor and high humor.

Price range of original work: $450 - $2500.

PO Box 9492, Berkeley, CA 94709 510·595·7510
Represented by *Harleen & Allen Fine Art*, 427 Bryant St, San Francisco, CA 94107 415·777·0920

RICHARDENE DYMOND

83 *Valley Oaks*
 Acrylic on canvas, 18x24". Artist's collection.

Richardene Dymond was born in Nebraska and moved to California when she was fifteen, living primarily in the Sacramento area. She is a self-taught artist, first inspired by a trip to Hawaii in 1970. She followed that trip with art workshops, highlighted by one taught by impressionist Gayle Robinson, at the Light House Art Center in Crescent City, California.

After retirement from the DMV, she moved to Galt, where trees, ever-changing skies and space have compelled her to create paintings that are enhanced by light and contrasting colors. She has used oils and pastel, presently preferring working with acrylics.

She is a member of the Pacific Art League in Santa Barbara. She has exhibited at the Sacramento Fine Arts Center in the Magnum Opus VII shows, the Garden Center in Sacramento, as well as at festivals and fairs.

Price range of original work: $500 - $1500.

890 Village Run Dr #102, Galt, CA 95632-2661 209·745·1732

DARCY DZIEDZIC

108 *Ayana's Birth*
 Photograph.

2419 SE 49th Ave #2, Portland, OR 97206-1822 503·233·9253

BIRDELL ELIASON

82 *Mexican Market*
 Watercolor, 14x18". Private collection.
82 *Matador*
 Oil, 24x20". Private collection.

Award winning Oregon born artist, Birdell Eliason, tries to capture memories from the past by combining ideas from her sketch book with places she visits, then researching her material to make a finished painting. Her sketchbook contains Victorian houses, people, trees, barns, children, flowers, or whatever suits her fancy and can be sketched from a car window.

Private and public places display her work in Spain, France, Africa, Germany, Japan, Mexico and throughout the United States. St John's Uihlein-Peter Gallery in Milwaukee, Wisconsin held a show for Eliason in 1995 with great success. Every year she paints portraits of homes in Mt Prospect for the Mt Prospect Historical Society's Annual Housewalk.

Price range of original work: $125 - $2000.

12 N Owen St, Mt Prospect, IL 60056 847·259·6166

SY ELLENS

76 *View from Above*
 Acrylic on watercolor paper, 24x19". Artist's collection.

As a young person, Sy Ellens began exploring his artistic interests by sketching animals, machinery and buildings on his family farm. This led to painting, using calendars and other pictures as models for exploring color, mixing and composition.

He graduated from Kendall School of Design and Western Michigan University. He has worked in a commercial art studio and taught art in high school and college.

His art is found in many private and corporate collections in this country and abroad. He is a member of several art associations, including the National Society of Artists, Allied Artists of America and Knickerbocker Artists. He is a signature member of the Pennsylvania Watercolor Society and The Western Colorado Watercolor Society. He has won many awards in national and international competitions.

The emphasis in his paintings is on the rhythms of color and texture. He likes to paint several layers of color, letting some of the color that is under show through the layer above. This technique gives the appearance of luminosity.

He states "I want to make the person's day a little better for having seen my paintings. I want them to go away uplifted."

326 W Kalamazoo Ave #304, Kalamazoo, MI 49007-3352
616·342·6326 Telephone/Fax

JAMES ELLISON

107 *Pilgrim*
 Oil, 24x48". Artist's collection.

James Ellison is a nationally and internationally award-winning artist holding the degrees of BFA, MA, MFA and MDiv.

"As an artist, educator and theologian, I create using a unique blend of aesthetics, theology and psychology. I believe we are all created in the image of God and are by nature creative beings. Thus in everyone there is a pure child-like spirit. God's will for our lives is revealed to this spirit through nature and human form in subtly different ways each day. In my paintings I communicate this divine will through a subconscious symbolism, so people can grasp the great and sublime which they have missed due to lifes dulling their senses and imprisoning their spirit. My desire is for the viewer to experience the celebration and struggle of one who is on a lifelong pilgrimage. I hope my paintings will resonate with their own joys and sorrows. I succeed when their spirits are stirred. In receiving this beauty born out of strife they recognize the worth

of their soul and are inspired to seek out new possibilities in life."

Price range of original work: $15,000 - $30,000.

2907 Blakeman Ave, Rowland Heights, CA 91748-4812
818·965·8184 Telephone/Fax E-mail: ELIARTIST@aol.com

DEMPSEY ESSICK

95 *Early Spring at the Fritts Farm*
 Watercolor, 13¾x19½". Private collection.

95 *Roxie's Touch*
 Watercolor, 17x25". Private collection.

Every artist brings to his work all the things that have influenced him throughout his life. Dempsey Essick is no exception. Growing up on a farm in Davidson County, North Carolina, Essick learned the traditional values of people who work with their hands. He has developed a reverence for the land and the history of the people who live on it.

Influenced by his own rural upbringing, Essick most often draws his inspiration from the surviving reminders of the agricultural south during the period just after the turn of the century. He feels that through his painting he is helping to preserve a glimpse of the history and life-style of bygone days.

A self-taught realist painter, he has, in a few short years, become one of the preeminent watercolorists in the eastern United States. His biannual print releases invariably sell out on the day they are released. The many collectors of his work appreciate his selection of subjects, the wealth of detail in each of his paintings as well as his deft touch with the small brush.

Price range of original work: $1000 - $15,000.

PO Box 1149, Welcome, NC 27374-1149 910·731·3499
910·731·3444 Fax

NOUZHA EVANS

98 *Collective Mind*
 Oil on cardboard, 12x12". Artist's collection.

Nouzha Evans was born in the Middle Atlas Mountains of Morocco, studied Sociology at the University of Grenoble, France and now lives and teaches art in California.

She is intrigued by the sky's light and fascinated by astrophysics. "I paint and experiment, "states Evans, "hoping that a simple set of colors will come out from the canvas to tell me that the experiment is right and to show me something similar to what we see through telescopes and microscopes."

In 1990 she threw all her concerns and colors into one question and searched for an answer within art: If Albert Einstein tried to paint the image of the Unified Field Theory, would the painting guide him to the single equation he was looking for? She took the question seriously because of the beauty of it's responsibility and worked on finding a way to paint Einstein's dream. She knew that to be true, the painting must have a special place for General Relativity and plenty of room for Quantum Physics. "The painting must simply match what the theory has to say and speak the common language that physicists are looking for."

Price range of original work: $100 - $10,000.

87 Elizabeth Wy, San Rafael, CA 94901 415·454·0895

WILLIAM M S FANG

66 *Fisherman's Song*
 Acrylic and ink, 26x36". Artist's collection.

William M S Fang was born in Hangzhou, China in 1939. He studied oriental arts from Chinese artist Lu WeiZhao. He also studied western painting at the University of Wisconsin.

Fang created "Random Lines" painting, based on George Seurat's creations. Random lines painting has an appearance of disarranged lines when viewed close-up, and a clear picture when viewing distantly. These paintings, focused on lines—the soul of Chinese paintings— express images with colorful lines naturally mixed in the viewer's eyes. The media is a mixture of acrylic and ink. "From disorder to order," is Fang's philosophy.

His first random line painting was created in 1987 in the U.S. and was exhibited at the Sing Tao Gallery in Toronto in 1990. His works have also been exhibited in New York and the Academy of Traditional Chinese Painting in Beijing, China.

Price range of original work: $300 - $3000.

458 Margueretta St, Toronto, Ont Canada M6H 3S5
416·537·8416 416·537·0435 Fax E-mail: AiqiLu@ipoline.com

WILLIAM M FEGAN

45 *Living Waters*
 Oil on linen, 56x78".

Born in Ft Worth, TX and reared in a climate that encouraged young talent, William M Fegan realized his own ability and desire for the future at the age of seven. He attended Southern Methodist University in Dallas, TX and graduated with a BFA in Painting. He has been exhibiting and selling his work since that time. His main focus for the past 20 years has been with the theme of water. A representational painter, he believes the abstract present in nature forms subtle forces that can influence our lives. When the viewer relaxes and lets his eyes wander, he may allow his unconscious to respond in a positive and healing way. Water is an archetype

Red Tile Floor by Faith Tyler

symbol of spiritual cleansing and renewal, which by its nature envelops our lives. Water, for Fegan, can best be seen through the refraction of light and the presence of koi. He never tires of painting the subject of water and looks forward to evolving its unlimited possibilities.

Price range of original work: $2000 - $4000.

1316 Conant, Dallas, TX 75207 214·631·2920 Telephone/Fax

PERLA FOX

86 *Lily Pads, No. 2*
 Watercolor, 20½x28½". Private collection.

Born in Washington, DC, Perla Fox first exhibited watercolors there in 1962. Since 1972 Fox has also lived and exhibited in Israel. Her work is in private collections in the U.S. and abroad, including: Bank of Maryland, Bethesda, MD; Herzlia Art Museum, Israel; and Bank Hapoalim, Israel.

Recent exhibits: ArtExpo New York & Los Angeles; Hendler Art Gallery, Baltimore, MD; Spector Gallery, Harrison, PA; Isart Exhibition, Tel Aviv, Israel; Dania Gallery, Haifa, Israel; Yaki Gallery, Jerusalem, Israel; Jacques Soussana Gallery, Jerusalem, Israel; Weisman Gallery, Beersheva, Israel; Images Modernes, Marseille, France.

Fox has had limited editions and calendars published. Greeting cards have also been published by Rudin. She has authored and illustrated the *Wooodles*, a children's whimsical picture, poetry and activity book. She is included in *Israel Painters & Sculptors*, 1981 and 1991; *Encyclopedia of Living Artists*, 1988-1997.

Price range of original work: $250 - $2500.

12314 Moorpark St #203, Studio City, CA 91604 818·509·7763

Represented by *Coriell Gallery*, Hyatt Hotel, Albuquerque, NM 505·243·6000; *Carol Schwartz Gallery*, Philadelphia, PA 215·242·4510; *AJW Fine Art Inc.*, Bethesda, MD 301·530·5832; *ArtiCircle Gallery*, Anchorage, AK 907·563·3578; *Jacques Soussana Gallery*, Jerusalem, Israel, 9722·782426 JSG Fax.

VERONICA GALATI

113 *Primary Crossing*
 Oil on canvas, 48x48". Private collection.

Veronica Galati's fine art nudes and sports figures express extraordinary intuitive awareness of the natural movement and anatomical structure of the human figure.

Recognition of this creative integration and Galati's highly visible powerful and energetic style are witnessed in corporation and private collections, gallery and museum exhibitions, both invitational and juried, and in the awards of museum curators of the Metropolitan Museum of Art, NY; Los Angeles County Museum, CA; and the Whitney Museum, NY.

Galati has a MA from Hunter College in New York.

Price range of original work: $3500 - $10,000.

335 E 70th St #9, New York, NY 10021 212·517·8393

LUDMILA GAYVORONSKY

12 *The End of My World*
 Oil on canvas, 36x36".

Listed in several editions of *Who's Who in International Art* and *Encyclopedia of Living Artists,* Gayvoronsky's art has been exhibited in major cities and galleries throughout the world. Her visceral expressionistic and at times hauntingly surreal paintings display her artistic vigor and compelling vision. Gayvoronsky's paintings often depict jesters, tricksters clothed in medieval-type garb, her favorite time in history.

She combines her past with her imagination to create mythical or allegorical settings for her work. She states, "I want to achieve a dreamlike, elusive, mysterious quality in my work. I would like to create a romantic mood and dramatic composition in every painting. I'm glorifying the past but I want my paintings to be relevant to the present. Something is askew in modern time and space, and traditional symbols and myths have lost much of their original meaning. Any honest revival of the figurative tradition will arise from the soul and imagination of individual artists inspired by the formal and spiritual potentials of the human body and the world around us."

Price range of original work: $1000 - $6000.

26 Church St #5, Newport, NH 03773 603·863·9919
E-mail: 76202.3053@compuserve.com

Untitled by Alex Chubotin

PATRICIA GEORGE

60 *Positano*
 Oil on canvas, 40x30". Private collection.

61 *Walkway in Capri*
 Oil on canvas, 36x48". Private collection.

61 *Miralago*
 Oil on canvas, 40x30". Private collection.

Patricia George is the recipient of numerous awards, including the Laureate Award given by the Mayor of Paris, France at the International Art Exhibit "Vieux de la Colombier." Her triptych *Morning at Mykonos* was exhibited at the Chapelle de la Sorbonne in Paris, France. Recently she was commissioned by the Disney

Corporation to create paintings for their Newport Coast Resort in Newport Beach, CA. The Hilton Corporation utilized her talents in the creation of four pieces for the World Trade Center Hilton in Long Beach, CA.

George is listed in *Who's Who in American Art*. Her paintings have been selected for many magazine covers. She was the winner of the cover contest for *Manhattan Arts*. Her paintings have been exhibited in Greece, France, Japan, Panama City, United Arab Republic, Australia, Canada and Cayman Islands. She is represented by galleries across the U.S. and Canada. Her work is available in originals and fine art prints. More paintings may be viewed on the Internet at the address below.

Price range of original work: $500 - $6000.

4141 Ball Rd Studio 221, Cypress, CA 90630 714·826·7945
714·995·5149 Fax
E-mail: pitsy@msn.com www.cdiguide.com/art/george

MITCHELL GIBSON

35 *Man to Man*
 Acrylic on canvas, 32x38".

35 *Emergence*
 Acrylic on canvas, 48x36". Private collection.

Mitchell Gibson's paintings explore a deep and rich spiritual life which over the past ten years has begun to find expression through a hauntingly beautiful and intensely creative painting style.

His paintings hang in private collections and corporate offices across the United States. Galleries which have carried his work: The Chosen Image Gallery, Philadelphia; The Lucien Crump Art Gallery, Philadelphia; The Arizona State University Downtown Center Gallery, Phoenix; The Scottsdale Center for the Arts, Scottsdale; The African-American Museum of Art; The Deland International Fall Festival of the Arts, Deland, FL; The Agora Gallery Visual Registry, Soho, NY; and Gallery Q, Tucson. His work may also be seen on the Angelnet International Exhibition for art based on dreams and visions on the Internet. Gibson's work will be featured in the 1997 Inaugural Grand Prix Arts Festival at the Empire Polo Club, Indio, CA.

"Spirituality is the current which flows through the fiber of all my canvases."

Price range of original work: $4000 - $160,000.

1201 S Alma School Rd #6950, Mesa, AZ 85210 602·644·0050
602·759·6195 Fax http:www:artscape.com

ADRIENNE GILLESPIE

100 *Pete's Harbor*
 Oil, 16x20". Artist's collection.

Except for intermittent sojourns overseas, Adrienne Gillespie has lived in Palo Alto. Her travels in Europe and Asia were motivated by the desire to experience the history of the arts of many nations. Her artistic training began at Foothill College and the Pacific Art League of Palo Alto, where she worked in pastel, watercolor and oil. Because she enjoys the outdoors, much of her painting is devoted to landscapes and seascapes. She tries to complete all her canvases on location, to capture the scene so that the result is a recognizable but not exact portrayal and to bring out the beauty which is overlooked by the casual observer. Strong contrasts of light and shadow are important elements in her compositions and help convey the mystery and excitement. When plein-aire painting is impractical, she works on traditional still life subjects in her studio, more recently attracting attention for her studies of children's toys. She exhibits frequently and her paintings have been bought by Bay Area and Eastern connoisseurs. She is an active volunteer at the Pacific Art League, serving as first vice-president.

Price range of original work: $150 - $575.

957 Matadero Ave, Palo Alto, CA 94306 415·856·9580
415·856·6024 Fax E-mail: 1gillespi@leland.stanford.edu

BARBARA GLANDER

28 *Sunset in Acapulco*
 Oil on canvas, 30x60". Artist's collection.

29 *Sundance*
 Oil on canvas, 30x60". Private collection.

Barbara Glander creates large textured oil paintings whose three-dimensional quality draws the viewer in, to create a feeling of tranquility. Her works have been used for stress reduction therapy and have proven to have a calming, soothing effect on an individual. Her artwork can be found in numerous medical facilities for use in biofeedback therapy, as well as many private collections worldwide. Glander has had several solo shows.

Price range of original work: $800 - $4000.

PO Box 31, Columbia, NJ 07832 908·453·4349
E-mail: bglander@bglander.com http//www.bglander.com

LOU GRAWCOCK

101 *Fun Guys*
 Pastel drawing, 18x24". Artist's collection.

Lou Grawcock has exhibited her work in national shows throughout the country, as well as in regional and local competitions. She is a pastellist and a print maker. In this latter medium, she is devoted to etchings. She obtained a BFA from Indiana University. Her goal as an artist is to capture in a romantic manner, the mood evoked in her by the subject of her work. Her rural Indiana background has given her a close association with the diversity of nature's beauty—from the serene, poetic beauty of a landscape to the mystical, geometric beauty of the fungi.

Grawcock sees art playing an important role in every home as a means of fostering a pleasing and tranquil environment that will enhance one's ability to relax and be rejuvenated.

Price range of original work: $50 - $600.

5971 S Woodstrail Dr #57, Columbia City, IN 46725-9418
219·691·2610

JACKIE GREBER

40 *Radiance Series II*
 Plexiglass, mirror and flamed copper, 29x23x2¾".
 Private collection.

Jackie Greber's sculpture evolves from constructivist and minimalist traditions and is an exploration of the properties of plexiglass and light in relation to visual aesthetics. Her work involves technology overlapping science and art, an exploration involving light, color, illusion and space, stemming from her scientific background in

the fields of biological sciences and psychology which she pursued to the doctorate level.

She hopes to slow the viewer down, to provide an island of serenity and balance, with its own presence. Her intent is not to pursue an intellectual or emotional issue, but rather a perceptual one.

Solo exhibits include: Molly Barnes Gallery, Los Angeles, CA; La Jolla Museum of Contemporary Art, La Jolla, CA; Loveland Museum, Loveland, CO; Inkfish Gallery, Denver, CO. Over 60 group exhibitions include Los Angeles County Museum of Art, Newport Harbor Art Museum, San Diego Institute of Art, all in California and Montserrat Gallery, New York. Recent exhibitions include Barcelona, Spain; Tokyo; North American Sculpture Exhibition, Art and Science Exhibit, Albuquerque, NM; and the Texas National '96.

1280 Estes St, Lakewood, CO 80215 303·237·8456

MARK GUDMUNDSEN

87 *Grand Teton Fall*
 Acrylic, 22x28".

Mark Gudmundsen is emerging as one of America's great landscape painters. He is challenged by the diversity of nature in various regions and is particularly interested in those unique areas contained in the National Parks. In 1983 he attained a BFA with distinction from California State University Long Beach. Gudmundsen has been the Resident Artist at the Tenaya Lodge at Yosemite since 1991.

Because of the fine detail and careful brushwork, a typical Gudmundsen painting might take over one hundred hours to complete. His paintings are often very realistic, nearly to the point of photo-realism, yet they have a depth and presence about them that transcends anything achievable on film. The viewer will often feel as if they could literally step through the canvas into the painted image. His works, some of which have won awards and honors, hang in museums, galleries and collections throughout the world.

Price range of original work: $800 - $5000.
51892 Quail Ridge Rd, Oakhurst, CA 93644 209·683·4308

LOIS HANNAH

83 *Bear and Bull*
 Bronze, 44x22x26". Private collection.

As a sculptor, Lois Hannah's passion is for form, be it animal, human or abstract. As a crafts person, she insists on quality. She started her own foundry to that end, which has gone on to commercial success. Her training, following graduation from art school in Vancouver, BC, Canada, was in the studios and foundries of artists in the south of England, followed by work in Canadian foundries.

Hannah's sculpture is noted for its accuracy and sensitivity, and blends a classical sense with close observation of nature. Her pieces achieve the dignity of a separate reality, the animals escape anthropomorphic "character."

Her exhibition list includes the West of England Academy. Her work is also in royal collections in Europe. Commissions include portraits of animals and people of all ages. Her work can be seen in several galleries in Canada and the U.S. and is collected internationally.

Price range of original work: $250 - $14,000.
21131 42nd Ave, Langley Canada BC V3A 5A4 604·533·0150

PATRICIA HAUSMANN

136 *Superimposed Bridges*
 Wood engraving, 8x10". Artist's collection.

Patricia Hausmann's art background consists of working at Walt Disney Productions as a cartoonist and attending Scripps College and UCLA to receive a BA in Art Education. She studied three years with Paul Landacre at Otis Art Institute. Now a retired art teacher, she currently concentrates on wood engraving. Prints have been exhibited in many major museums, including Hawaii, Los Angeles, and Palm Springs. Awards include: First Place International Competition, *Manhattan Arts* magazine and two bronze awards for oil paintings featured by *California Arts* magazine. Prints are currently on a CD-Rom promoted by Art Communication International. 1997 will see twelve of her prints on the Internet with representation through ACI.

Engravings are not devoid of color, for she sees color as changing values of black through white. Hers is a world of undulating and piercing lines, of textures and shapes; these lines result in an abstraction of nature and man-made objects.

Price range of original work: $90 - $200.
728 Cordova Ave, Glendale, CA 91206-2114 818·241·3709
http://www.artcommunications.com

ROSEMARY HENDLER

13 *Pear and Straw*
 Computer, 24x28". Private collection.

Rosemary Hendler has a BA in painting from UC Berkeley. She has been a practicing artist for the past 30 years. Two years ago she closed her studio and entered the world of computer art, not to look back!

She has had numerous solo shows and has won several awards for her digital art pieces. She draws and paints on her computer and transfers the images to canvas, watercolor paper or fabric. On a special printer, her work can be taken from a computer disc and transferred to acrylic paint on canvas. Pieces can then be worked over with more acrylic paint. The electric world has expanded her horizons with no sacrifice to classic values. It has allowed her to translate the visions of her mind's eye in a fraction of the time previously needed. Although she has mastered almost every traditional medium, it is exciting to realize that there is now another medium to explore and learn.

Price range of original work: $300 - $2000.
16 Verano Rd, Orinda, CA 94563 510·254·9178
510·253·9623 Fax E-mail: rosemary-hendler@designlink.com

HELI HOFMANN

102 *Summer*
 Oil on canvas, 36x36". Private collection.

102 *Beautiful Bavaria*
 Oil on canvas, 36x36". Artist's collection.

Heli Hofmann is a native to the Bavarian area of Germany. She became inspired by the paintings of Expressionist painters such as Kandinksy, Jawlensky, Paul Mondersohn-Becker and Gabriele Münter. Hofmann's paintings reflect the influence of the French Fauvist movement led by Matisse and the Blaue Reiter group formed by Kandinsky, Franz Marc and August Macke. In 1978, she emigrated to the United States.

Hofmann's oil paintings are expressive and stylized. Her landscapes, still-lifes and faces are also characterized by the use of rich, vibrant color. The composition is exciting and striking. Her subjects are influenced by her visual experiences gained from worldwide travel.

Her work was accepted into the San Diego Museum of Art, All California Juried Competition 1993. She received a Silver Discovery Award the same year from the *Art of California* competition. Now her paintings are shown in international competitions. Her work is in private collection in three continents.

Price range of original work: $2000 - $4000.

5870 Cactus Way, La Jolla, CA 92037-7069 619·459·4610 619·459·1754 Fax http://www.infopost.com/heliart/

DEBEE L HOLLAND-OLSON

43 *Evening Light on Limestone Ridge*
 Pastel, 46x37". Private collection.

Debee L Holland-Olson vividly and unequivocally depicts California's Pacific North coast landscape, a terrain of vast space and intense light. She often returns to the same site over and over, as each visit brings a new physical presence and atmospheric condition.

"It's important for me," she states, "to be in touch with the elements that are influential in portraying the site I have chosen to paint. I work in pastel and dry pigment. This technique allows me to react to the rapidly changing atmospheric light found in the Pacific Northwest. Dense sweeping application of dry pigment in my pastel paintings provides a dramatic medium to express the mystery of rolling fog as it mutes and chills a once brilliant landscape."

Holland-Olson engages in exploring the gap between the actual landscape of inspiration and the painting of the landscape, the gap between nature and art.

Her work can be found in corporate and private collections in the United States. She is currently seeking gallery representation, as well as accepting commissions.

Price range of original work: $600 - $5000.

224 Main St, PO Box 1805, Weaverville, CA 96093 916·623·2819 916·623·142 Fax
Represented by *William Zimmer Gallery*, PO Box 263, Mendocino, CA 95460 707·937·5121 707·937·2405 Fax

ALVIN C HOLLINGSWORTH

18 *Phenomenal Woman*
 Oil, acrylic and collage, 33x24".

18 *Masquerade*
 Oil and acrylic, 36x24".

19 *Night in Tunisia*
 Oil, acrylic and collage on wood, 48x58".

Ballerina by Bill King

Alvin C Hollingsworth is a native New Yorker and full professor at CUNY. He devotes his nonteaching time to painting. He is noted by Jeanne Siegal in *Artwords* as one of the leading painters in the country. Hollingsworth's works are in the collections of IBM, Chase and the Brooklyn Museum, as well as many private collections nationwide.

He recently held a show in New York, sponsored by the Georgia McMurray Group, entitled "Visions of Life," which included his religious, psychological and jazz images, as well as scenes of women.

A monograph entitled *Images of Women* is in the process of being published.

614 W 147th St, New York, NY 10031
Represented by *Allan Stone Gallery*, 113 E 90th St, New York, NY 10128

GEORGE E HOMSY

68 *Astronauts*
 Oil on canvas, 10x8".

69 *Upstairs/Downstairs*
 Mixed media on paper, 15x11".

George E Homsy is primarily an abstract artist who incorporates the human form and human condition into his works. Ethereal washes of color coalesce in evanescent patterns and forms deftly and delicately emerge from them. The ebullient other-worldly beings that he creates not only appeal to the viewer's visual appetite but awaken the poet, the mystic and the dreamer. Among the influences evident in his creativity are the twentieth-century painters Chagall and Redon. Homsy nonetheless has developed a totally distinctive style.

In 1993 the award winning artist began exhibiting his work and was soon granted his first solo show in 1994 in New York. A succession of important shows followed in the U.S., Canada, Europe, the Middle East and the Caribbean. His work is in private collections in many countries. At the present time Homsy's work is on permanent exhibit at the Abney Gallery in New York. His work is available in originals as well as limited edition fine art prints.

Price range of original work: $100 - $5000.

119 Greenway S, Forest Hills, NY 11375 718·261·5729

MARK HOPKINS

124 *Zygote Origins*
Oil, 18x18x18". Artist's collection.

Mark Hopkins was born in Poughkeepsie in 1959. After graduating from Saint Olaf College in Northfield, MN, he attended a foreign study program in Japan, Taiwan, and Thailand where he began his lifelong interest in Asian cultures. He lived in Minneapolis, working as a free-lance artist and scenic painter for several theatrical companies, including the Minnesota Opera Co and the Guthrie Theater, until moving to Asia in 1987. He worked in the studio for a year before opening a popular cultural cabaret in Northern Thailand. He resumed studio work in 1990 working in Indonesia, Singapore, New York and Thailand. He is currently living in Bali, illustrating an encyclopedia on Indonesia.

Hopkins' artwork ranges from portraiture to symbolic/surreal and aims at expressing the unspoken humanness that all human beings share. *Zygote Origins* acknowledges the derivation of the zygote symbol from that of yin-yang in Chinese art. Both are binary and speak of the wholeness and balance that underlie the universe. Unlike yin-yang, the zygote speaks of science and the beginnings of human life.

Price range of original work: $250 - $10,000.
70 Whittier Blvd, Poughkeepsie, NY 12603-4116
914·454·2028 Telephone E-mail: mhopart@mhv.net
http://hudsonvalley.com/MarkHopkins.Art

FRANK JALSOVSKY

26 *Tribute to Leonardo*
Intaglio, 25⅓x19⅓". Artist's collection.

27 *Genesis*
Intaglio, 31⅔x27". Artist's collection.

Born and educated in Slovakia, Frank Jalsovsky brings to his art a singular vision of a world far removed from present-day experience. During his formative years in Bratislava, Slovakia, his works reflected an emerging philosophical awareness of the nature of human endeavor, the complexity of universal energies and forces, and their inherent interrelationships. Traditional themes, including landscape, portraiture, and figurative works carried with them the undeniable symbology of human aspiration for something greater than humanity.

Since 1990 he has continued to dedicate his artistic career to the articulation of his personal philosophy on the essence of the human condition and the eternal quest for universal understanding. He mostly uses techniques of etching, aquatint, mezzotint, drypoint, heliogravure and photoetching.

Jalsovsky's works can be found in many galleries and private collections in Slovakia, Austria, USA, Canada, Japan, Taiwan, Korea, France, Spain, England and Peru.

Price range of original work: $1500 - $25,000.
1205 Johnson St #209, Coquitlam, BC Canada V3B 7G4
604·941·5621 Telephone/Fax http://www.wordplay.com/jalsovsky/

JIAN-KANG JIN

96 *Instinct of Love*
Oil on canvas, 78x78". Artist's collection.

Jian-Kang Jin was born in Shanghai, China in 1957. He was awarded a scholarship in Fine Arts to Shanghai Teachers' University in 1985. Jin then taught fine arts in the Shanghai Publications Institute.

His art is characterized by emotions expressed in a realistic style using oils and pastels. He makes aspects of China accessible to non-Chinese viewers, thus bridging two very different cultures. He received many favorable international reviews in magazines and newspapers.

In Paris, he studied and researched fine arts independently for two years. He then attended the Academy of Fine Arts in Florence for another two years. In the United States, Jin obtained a Master of Arts from New York University in 1992. He has exhibited widely in China, France and Italy, as well as in the United States.

Price range of original work: $5000 - $8000.
1693 Grove St, Ridgewood, NY 11385 718·628·1115
718·628·0358 Fax

MARNIE JOHNSON

1 *Fantasy*
Oil on board, 30x34". Private collection.

141 *Contemporary Eve*
Oil on board, 36x28". Artist's collection.

Marnie Johnson was born in Borger, TX in 1954. As a young girl she studied painting under her father, Bob Johnson. Later in California, she attended the Santa Barbara Art Institute, Art Center College of Design and as a scholarship student studied under the Russian painter Sergei Bongart.

Since 1978 Johnson has been living in New Mexico and has exhibited her work in solo and group shows, galleries and museums across the nation.

"Marnie Johnson's work displays an uncommon sensitivity for the quiet poetry of everyday living; it has a singing energy that praises the beauty and dignity of simple things." Steve Parks, *Artlines*

"Marnie's paintings are striking. The colors are crisp and luminous

Hebe and Ganymede, Cup-Bearers to the Gods by Rosemary Morison

and her handling of light is masterful." S.D.., *Taos News*
Her work may be seen at the Dartmouth Street Gallery, Albuquerque, NM; Charlene Cody, Santa Fe, NM; Mulligan-Shanoski, San Francisco, CA; and Craighead-Green in Dallas, TX.
Price range of original work: $650 - $9500.
513 S Jemez, Santa Fe, NM 87505 505·471·0108

LISA JONES-MOORE

50 *Summer Reading*
 Pastel, 10x18½". Artist's collection.

50 *Domestic Landscape #2*
 Pastel, 16½x22½". Artist's collection.

Lisa Jones-Moore approaches each painting with color and light in mind. Her still-lifes become 'micro-landscapes.' She focuses on the essence and dynamism of the moment. Distillation down to just 'pure color' would accurately describe Jones-Moore's approach to any painting. Pastels and oils are her media of choice because she can easily manipulate color nuances.

It is Jones-Moore's hope that whoever is viewing her paintings feels the dynamic life-moment that she feels while painting. She has always been inspired by the Impressionists—both French and American. "I try to perceive color and light as the Impressionists did—especially Monet. I will continue this endeavor for the rest of my life. Because of my extensive graphic design background, I am constantly pursuing illustration opportunities, as well as fine art."

Jones-Moore graduated from Colorado State University in 1981, with a BFA. Since that time, she has worked as a graphic designer, illustrator and painter. She is a member of the Northwest Pastel Society. Her award-winning work has been seen in many Seattle area exhibitions.

Price range of original work: $295 - $2000.
PO Box 1351, Edmonds, WA 98020-1351 206·774·1432

MARIA DELIA BERNATE KANTER

42 *Adrienne's Dream*
 Acrylic, 36x60". Artist's collection.

"Sometimes one recalls the magic of 'Le Douanier'—the impression of palms, of trees never seen, of indescribable, anonymous flowers that surround inhabitants of this intricate jungle where wilderness roams. Sometimes we think of Sonia Delaunay's vibrant clusters of light. Or we think of Franz Marc and fancifully whisk magentas and violets at emerald greens braided with jades and deities that we see before us. These images lead us towards the origins of incredible forms and colors. But Maria delia Bernate Kanter, a Colombian from Tolima, is neither a disciple of 'Le Douanier' nor of Delaunay. She has not been influenced by the creator of those blue deer (Chagall), but since we are dealing with a brilliant creator of dreams, we should associate her with those artists who have also created dreams.

That explains why Kanter—like Delaunay, Rousseau, Marc—is one of those rare painters who can bring to real life, with the power Supervielle and Elouard had in letters, the *colors of dreams.*"
 Excerpts from a translation of *The Colors of Dreams* by
 Alejandro Carrion, Ecuadorian novelist and art critic

Price range of original work: $1200 - $9000.
6155 La Gorce Dr, Miami Beach, FL 33140
305·865·9406 Telephone/Fax

ROBERT F KAUFFMANN

132 *Magnetically Distorted City*
 Serigraph, 18x24". Artist's collection.

Robert F Kauffmann received a BA in Computer Science from Rutgers U in 1988. His artwork has been shown in a number of galleries and other venues in New York City, including the Salmagundi Club, Westbeth Gallery, and has been reviewed in various publications, including *Manhattan Arts International* and *Artspeak* He is currently completing an animated film entitled *Animated Shorts*.

Kauffmann's art consists of graphic designs rendered in exacting detail and printed as serigraphs. They typically portray visual

That's Me by Peggy Palletti

paradox using mathematical structures as expressive tools. His artistic style follows from his professional and academic background in computer science and mathematics, as well as the work of MC Escher and B Mandelbrot, a mathematician and inventor of fractal geometry. His style can best be described as Mathematical Surrealism.

Price range of work: $200 - $500.
2401 Arden Rd, Cinnaminson, NJ 08077-3061 609·829·7725

EVA KEKY-MAGYAR

14 *Going Together*
 Encaustic/glass textile, 56x46". Artist's collection.

15 *Uniting Heaven and Earth*
 Encaustic/glass textile, 46x56". Artist's collection.

Eva Kéky-Magyar has studied in Hungary, West Germany and France and was invited to teach in Australia. She has had group shows as well as solo shows in Europe, Australia and the United States.

She is in the collections of Art Gallery of NSW, Sydney; Commonwealth Collection Canberra, Australia; Queen Victoria Museum, Launceston, Tasmania; Smithsonian Institute, Washington, DC; also in Hungary and Bulgaria, as well as in private collections worldwide.

Zygote Origins by Mark Hopkins

She has received award from and honorary membership in Masaryk Akademy of Fine Arts, Prague. She was awarded the Czech-Bavarian Art Society, and silver prize from Graphics Triennale Prague 1994.
She is listed in: *The Arts in Australia* 1965; *Encyclopedia of Australian Art* 1968; *25 Jahne Geseltschaft der Freunde Junger Kunst* 1980; *Magyar festok es grafikusok adattara* 1988; *Vt Durantuli Tariat Kaposvar* 1987 and 1990; *Pannonia Triennale* 1989; *Eletunk* 1988, *Who's Who in American Art 21 Edition*, and reviewed in *Artspeak*.
Price range of original work: $1500 - $9600.
Szombathely Kilato-ut 12, H-9700 Hungary 36·94·315·910

BETSY M KELLUM

93 *Sculpture and Peaches on Mahogany*
 Pastel, 24x18". Artist's collection.

Betsy M Kellum has shown her work nationally and internationally in exhibitions at the Pastel Society of America, Allied Artists, Pastel Society of the West Coast, as well as many others.
Working primarily in pastel, Kellum uses a representational style with rich color and dynamic value changes. Still lifes are her passion as this subject matter allows her to establish color harmony with a limited palette and to control the lighting. Strict attention is paid to the interaction of the objects in the paintings with their environment; how the colors influence each other and what happens when reflections and shadows overlap and mingle. This concept is illustrated in her series of paintings on mahogany, whether the subject is flowers, marbles, ribbon, fruit or toys.
"I find a sense of peace and simplicity in our hectic and stressful world when I examine the beauty found in simple objects that we take for granted and often overlook. I hope my viewers can pause for just a moment to share that feeling through my work."
Price range of original work: $500 - $2500.
2808 Sugarberry Ln, Midlothian, VA 23113 804·897·0449

PATI KENT

134 *Jammin*
 Mixed media, 14x16". Artist's collection.

Pati Kent is an author and illustrator. She received her formal art training, graduating from Art Center College of Design in Pasadena, CA. She is well-known for her poetic multimedia paintings. Her prominent style has developed from experimenting with a combination of media. Her work is often inspired through her in-depth study of historical events and humanity. Her work has been shown in many national and local competitions, gallery shows and printed in a variety of publications. She has won several awards and recognitions for her work.
Kent delights in writing verse and poetry and is especially enthusiastic when merging verse with images. Jammin is one in a four-piece series celebrating the visionary Bob Marley. "Too many people not understanding where we are commin' from. Understand the need for the world to be at one."
Price range of original work: $150 - $2500.
619 16th St, Huntington Beach, CA 92648-4015 714·536·4974
714·536·4917 Fax

HEE SOOK KIM

22 *Iron Woman*
 Artificial flowers, gloves, fabric, wood on veneer, 30x14". Artist's collection.

Hee Sook Kim has a MA from New York University and MFA from Seoul National University. She has won several awards including Pollock-Krasner Foundation Grant and residency grants. She has held national and international exhibitions including major museum shows. She expresses the roles and various psychological and spiritual aspects of women in feministic ideas using fabric, wood, silk flower, oil, acrylic & photo. She is assistant professor in Clarion University in Pennsylvania teaching art and design.
Price range of original work: $150 - $8000.
116 Mercer St #5Fl, New York, NY 10012-3806
212·274·0142 Telephone/Fax

BILL KING

121 *Ballerina*
 Handcut glass, 25x9x7". Artist's collection.

Bill King was born in New York and began his career with a fascination for design and a constant desire to explore new challenges. After several years of painting he devoted his career to sculpture, making a commitment to sculpt annealed glass. Achieving his goal took years of experimentation, resulting in a style he developed and refers to as 'Glass Sculpting.' This arduous technique creates hundreds of facets which reflect light, adding greater depth to clear glass. Each original design is copyright and takes from six months to a year to complete.
His glass sculptures were honored from their first introduction: winning the New American Glass Show, the cover of *Wine Country International,* and the California Discovery Awards. Today his sculptures are privately owned and displayed at Tiffany & Co, hotels and public buildings worldwide.
Price range of original work: $2000 - $250,000.
935 Genter St #3D, La Jolla, CA 92037-5519
619·459·0051 Telephone/Fax

M A KLEIN

126 *Sunset to Dusk*
Mixed media fiber collage, 78x42". Private collection.

A professional artist for 30 years, MA Klein's contemporary narrative mixed-media collages hang in numerous corporate, public and private collections in the U.S. and abroad.
Her work embodies the use of acrylic painting on hand-dyed fabrics which are manipulated and collaged onto canvas or paper. Hand and machine stitchery, padding and wrapping are often added, resulting in highly textured pieces. The entire surface is protected with an acrylic medium, making it very durable and colorfast. The resulting one-of-a-kind creations are particularly suitable for public display as wall art, murals, banners or mobiles. Noted for her vibrant use of color and energetic groupings of landscapes, people, animals, birds and fish, she is inspired and excited by images and patterns in nature and by close observation of human and animal behavior.
Klein recently completed a large commission for the Library of Congress, Washington, DC and enjoys the challenge of commissioned work particularly with clients who share her love of color and texture.
Price range of original work: $300 - $25,000
4542 Ladera Wy, Carmichael, CA 95608 916·962·1432
916·962·1806 Fax E-mail: Maklein240@aol.com

ROBERT KOGGE

57 *Still Life with a Light*
Colored pencil and wash on canvas, 11x20".
Artist's collection.

Robert Kogge's work is a union of painting and drawing—a result of preparatory drawings for oil painting growing beyond their purpose to completed works. He began drawing directly on unprimed canvas with graphite and presently is using colored pencils over a tonal ground of wash and sizing.
Still-lifes and landscapes are his current focus. Kogge is particularly interested in the seemingly random and whimsical way landscapes change through human endeavor. He sees this process as an ongoing record of human nature. At a more accelerated pace and smaller in scale, still-lifes, or "real still-lifes," as they collect and disperse in all dwellings, bare a more personal, but similar record of human nature. A state of constant but gradual change, through the passing of time and human endeavor, is the common thread he tries to convey in his work—images that are appearing or disappearing or both.
He tries to draw something uncommon from the commonplace, and to offer a space of refuge for the imagination from physical existence.
Price range of original work: $2000 - $5000.
6603 Blvd East #27, West New York, NJ 07093 201·861·8126

GILDA KOLKEY

98 *Ominia Vanitas*
Oil on canvas, 24x48". Artist's collection.

Gilda Kolkey graduated from The University of Illinois in Champaign with a BA in Painting. Her early work, imaginative and whimsical, has shifted from story telling to a more contemporary, mysterious, and colorful direction.
Selected exhibitions: Art Institute of Chicago Vicinity shows; Tavern Club of Chicago, Women of the Tavern Club Annual Exhibition; Gallery Ten, Rockford, IL; The Evanston Woman's Club, North Shore Art League.
Collections: Dr & Mrs I Belgrade; Mr & Mrs Richard Weiner of Highland Park; Mr Rich Abreu; Mr S Frolichstein; Mr Shawn Bisceglia.
A member of the Chicago Society of Artists; The Arts Club of Chicago. Represented in *The Chicago Art Revue* and *Who's Who of American Women 1995-1996* and *Who's Who in America* and *Who's Who in the Midwest*. She has received a number of awards, including Woman's Club of Evanston, North Shore Art League, New Horizons, and Hubbard Woods Art Fair.
1100 N Lake Shore Dr #21-B, Chicago, IL 60611-1017
312·787·3516

MAREK KOSIBA

41 *Duet*
Acrylic on canvas, 48x64". Artist's collection.

41 *Eva*
Acrylic on canvas, 48x31". Artist's collection.

Chicago artist Marek Kosiba, a native of Poland, has been painting for over thirty years. After studying physics in college, Kosiba spent time at sea in the Polish Navy. Standing for hours on the Captain's bridge, looking at the water, he began to see two worlds—one under the surface of the water and one above the surface. The space between the two worlds—the actual surface of the water—is this space which he paints symbolically in his work. Instead of the traditional seascape, the artist paints in the abstract, showing how light and sharp objects pierce the surface of the sea. Another series of Kosiba's paintings evolved after numerous trips to Africa—the recurring appearance of lips are his symbolic visions of tribal masks.
Kosiba has had numerous solo and group exhibitions throughout

Cradle #2 by Tanya Ragir

Eastern Europe, Europe and the United States. His work is in many public and private collections including the Maison Internacionale des Gents de Mar, Rouen, France; the Polish National Museum, Walbrzych, Poland; and the Polish Maritime Museum, Gdansk, Poland.

Price range of original work: $600-$4000.

118 N Peoria #3Fl, Chicago, IL 60607 312·421·2025

NORBERT H KOX

80 *O Death Where is Thy Sting: Yesu Christ the Fountain of Life*
Acrylic and oil on canvas, 96x48 ". Artist's collection.

Norbert H Kox is a self-taught neo-naive visionary artist with a prophetic futuristic vision. The term naive refers to a movement of self-taught artists who usually have little formal education. Their subject matter is often of a spiritual or religious nature and extremely expressive.

Naive artists find vitality in intuitive expression that seems void of ego centricity. To the naive artist it seems as if a creator larger than their human self has been at work through their hands. Neo-naive artists allow these religious sensibilities to add depth and significance to their inquiry.

Kox's paintings expose evil, often through the dismal and horrific elements in society. These works can be viewed formally, read symbolically or literally interpreted through the scriptural references and texts within.

Kox's work has been recognized both nationally and internationally. *Raw Vision* of London published a feature article "The Apocalyptic Visual Parables of Norbert H Kox" in the 3/96 issue.

Price range of original work: $1500 - $60,000.

PO Box 109, New Franken, WI 54229 414·866·9187
Represented by *Dean Jensen Gallery,* Milwaukee, WI

BONNIE KWAN HUO

74 *Fair Lady*
Watercolor, 51x26 ". Private collection.

Born in China, raised in Hong Kong, Bonnie Kwan Huo has lived many years in the United States and Canada. Being a modern Chinese woman, she has a special fervor for painting Chineses beauties, graciously depicting their genteel disposition and charm. Her sensitive and refined style, together with her choice of pearly pastel colors, reflect her natural creative inclination.

Kwan Huo has exhibited extensively in North America and Asia. Her works are in the collections of art museums, corporations and private collectors around the world. Her work was selected for the Sotheby's Fine Modern Chinese Painting Auction. She is a member of the Federation of Canadian Artists and Hong Kong Artists Assocation.

"I believe that art is an extension of the artist. Good art wiil stand the test of time. In order to achieve that, an artist has to be true to him/her self in belief, emotion and action—totally involving oneself in the process of creation. The love and spirit of the artist will then shine through the work."

Price range of original work: $300 - $5000.

140-8380 Lansdowne Rd #271, Richmond, BC Canada V6X 1B9
604·271·1833

Sunset to Dusk by M A Klein

SILJA TALIKKA LAHTINEN

36 *Wild Rivers - Gypsy Violins*
Silkscreen on arches paper, 15x22 ." Private collection.

37 *Ritual*
Intaglio, 15x11 ". Private collection.

Born in Finland, Silja Talikka Lahtinen received a BA and MA from Helsinki University. She also attended Taideteoll Oppilaitos, Helsinki; Atlanta College of Art, GA; and Maryland Institute, College of Art, Maryland.

"All I ever wanted was to do the best painting. My instrument is myself and my style is what I am."

Lahtinen has exhibited in New York City as well as across the United States, Finland and France. Recent exhibitions include: Telfair Museum of Art, Savannah, GA 1995; San Bernardino Museum, Inland Exhibition XXXI 1995; Rutgers National 94, Stedman Gallery at Rutgers University, Camden, NJ; The City of Atlanta Gallery at Chastain, Atlanta, GA; OIA Salon 94, NYC; Ward-Nasse Gallery in New York; Spruill Art Center, Atlanta, GA 1994; Albany Museum of Art, Albany, GA 1994.

Included in *Who's Who in American Art* 1995-1996 Edition, *Guild Gallery* 1994-1995 Edition, *Burrough Index* 1995.

Price range of original work: $250 - $4500.

5220 Sunset Tr, Marietta, GA 30068 770·992·8380
770·992·0350 Fax
Represented by *Ward-Nasse Gallery*, 178 Prince St, New York, NY 10012 212·925·6951; *Galerie De L'Escallier,* 5 rue Keller, 75011 Paris, France

WENDY LANE

9 *Cattails 1994*
Oil pastel, conte, crayon on paper, 30x22 ".
Private collection.

9 *Minnesota River Drainage 1994*
Oil pastel on paper, 30x22 ". Private collection.

Wendy Lane's pastel drawings and acrylic landscape paintings are inspired by protected lands—parks, refuges, historic and sacred sites. In 1993 she was an artist-in-residence at Yellowstone National Park. In 1994 she became artist-in-residence at the Minnesota Valley National Wildlife Refuge.

"Through plein-aire painting, I seek to develop and express my personal understanding of a particular geography. I've hiked, camped and painted alongside the Minnesota River from its source at the continental divide in Brown's Valley to its confluence with the Mississippi in St Paul, Minnesota. I've researched the river's historic and contemporary uses and related environmental issues. My art stimulates interest in the river, encourages others to explore their relationship to the environment, and assists the refuge in educating people about the need to care for this great natural resource."

Lane received her MFA in painting from the Minneapolis College of Art and Design, and a BA in arts administration from Metropolitan State U in MN.

Price range of original work: $250-$1000.

275 E Fourth St, Northwestern Bldg, Studio 820, St Paul, MN 55101-1628 612·802·0688 612·224·1820 Fax
E-mail: wendy_lane@ordway.org

OVIDIU LEBEJOARA

81 *City of Angels*
 Oil, 36x48". Private collection.

Ovidiu Lebejoara was born in Romania in 1952. Since 1986 he has lived in Los Angeles. His compositions are an original approach to the interpretation of nature in simple terms: water, light, food, and energy. Ranging in style from surrealism to realism, he has built a distilled vision of reality where nature's light and life's perennial mystery compose a personal symbolism that speaks through elaborate colors and pictorial forms. Lebejoara forgoes the distraction of superfluous and melodramatic abstraction in favor of a cohesive portrait that gives the viewer a rest from a turbulent and noisy world.

His strong, well-conceived and esthetically challenging paintings reveal professional attributes in style, technique and concept. Both his older work and his current ongoing series of paintings show a distinctive style and contend that he has developed a personal, expressive signature, providing a way for exhibitors and collectors to identify his work.

His work has been featured in prestigious shows in Kansas, California, New York, Washington DC, Massachusetts, Virginia, Georgia, Texas and Tennessee as well as in Bordeaux and Paris, France and Romania.

Price range of original work: $500 - $15,000.

3115 Montrose Ave #12, Glendale, CA 91214 818·541·0146

DARNELL LEE

52 *Annie Mae: A Friend*
 Acrylic, 11x8". Artist's collection.

Darnell Lee is a graduate of Indiana State University with a BS in graphic design/fine art. He has had works published by Scafa-Tornabene and Foxman's. He was a recent winner in Art Instruction Schools art competition, the professional division in Minnesota. He has also had a number of exhibits, recently in the Olympic city of Atlanta, GA. He was recently accepted to exhibition in Agora Gallery in Soho, New York. Lee's work is realistic and heavily detailed. He is not, however, limited to realism, also doing impressionism, surrealism and abstract art. "Art is a necessity of the world."

Price range of original work: $25 - $300.

PO Box 77752, Atlanta, GA 30357-1752 404·659·8608

EDWARD HONG LIM

40 *Wake Up the Sleeping Soul*
 Oil, 30x26." Artist's collection.

Edward Hong Lim started his art career in Shanghai, China, where his works appeared in the Art Museum and were also published. In the early eighties, he came to San Francisco to explore abstract art. The Academy of Art College in San Francisco awarded him a scholarship for studying fine arts. He has been a member of the San Francisco Society of Illustrators. Many renowned domestic and international institutions have collected his paintings: The Air Force Museum in Washington DC, Chevron, Qantas Airways, Bank of America, etc. His works have been shown in international exhibitions. He won a mayoral honor for the 1994 Taipei Annual Arts Competition that took place in the Modern Art Museum of the Republic of China. His artistic aesthetics is to absorb visual arts in history, philosophy, physical power and make abstract images friendly to human surroundings.

Price range of original work: $1000 - $20,000.

2696 17th Ave, San Francisco, CA 94116 415·664·0709
415·664·0830 Fax E-mail: SLIM740014

ANN JAMES MASSEY

62 *The Marionette Shop*
 Oil, 20x16". Private collection.

From her first art competition in 1972, Ann James Massey has won awards and received recognition for her intricate pencil drawings. Upon entering her first competitions in New York, she won awards in all three; The American Artists Professional League, the Allied Artists of America, and the Knickerbocker Artists. When she entered her first three international miniature art exhibitions, she again took awards in each. In 1991 Massey followed the same path with her paintings, winning the Best of Show Purchase Award of $6,500, for Sierra Medical Center's Annual El Paso Art Association Exhibition at the El Paso Museum of Art. She is listed in *Who's Who in American Art*. Her work has been featured in numerous national magazines, including *Artist's Magazine* and *American Artist*, six books including *The Best of Colored Pencil* series and *Colored Pencil Basics*. Her work has been shown in many solo, group, national and international exhibits, as well as galleries and museums, and is in collections around the world.

Price range of original work: $500 - $10,000.

4, rue Auguste Chabrières, 75015 Paris, France
01133·01·4250·7245 01133·01·4043·9038 Fax
Represented by *Holly Denney*, 1515 Camino Alto, El Paso, TX 79902 915·533·0936 915·532·3862 Fax

LORNA MASSIE

21 *Veronica's View*
 Serigraph, 20x30". Private collection.

21 *Moon Cat*
 Serigraph, 26x23". Private collection.

Lorna Massie has received many awards for her hand-pulled screen prints (serigraphs) including both the Nicholas Reale Memorial Award and the Helen Open Oehler Award from the Allied Artists of America (NYC), the Philip Isenberg Award from the Knickerbocker Artists (NYC) and the Hudson Valley Art Association Award. Although the many technical steps of the printing process can be strenuous and time-consuming, there is pleasure in the process, the sensual oozing of thick, bright inks on to clean white rag paper, combining finally into something new. Massie says, "I like the simplicity of prints. The challenge is to reduce an infinity of colors and lines to an abstraction which has its own peculiar force."

Massie's subject matter deals with local landscapes, friends, animals and water. Massie's prints are in many public and private collections and have been widely exhibited nationally and internationally. She is listed in *Who's Who in American Art*, *Who's Who of American Women*, *Printworld Directory* and *Art Print Index*.

Price range of original work: $75 - $350.

452 Whitfield Rd, Accord, NY 12404
914·687·7744 Telephone/Fax

RHONDA McENROE

94 *Sheer Delight*
 Watercolor, 30x20". Artist's collection.

94 *Spectrum Shadow*
 Watercolor, 34x25". Artist's collection.

Rhonda McEnroe is a self-taught artist whose eye for detail and delicate touch with transparent watercolors has proven to be an invaluable combination. Since 1979, McEnroe successfully published 20 limited and open edition prints, the first 19 images being sold out.

Born in Kentucky, she has travelled, exhibited and sold her work from coast-to-coast. The Selene Galleria in Milano, Italy was the first solo exhibit after she received the prestigious China Trophy Award and the La Maschera D'Oro Award through the competition of the ItalArt Association in Milan and Venice. Her second solo show was in Cremona and the third in Bologna.

"My love for Italy and its people is obvious in the subjects of my paintings. The most important denominator for me is the people. The international friendships that I have made and nurtured in Italy and the Czech Republic are a vital part of my life. I must paint. I must create. I must be challenged. Because of my unbound energy for life and art, I enjoy a range of creative interpretations. My portfolio includes realistic and impressionistic works in watercolor, acrylic and oils; plus dramatic abstracts in a ray of mixed media."

Price range of original work: $3000 - $20,000.

47837 24th St, Mattawan, MI 49071-9704 616·668·8281

RENEE McGINNIS

111 *Gray Area*
 Oil/gold leaf, 68x42". Artist's collection.

Renee McGinnis grew up on a farm in central Illinois. She earned a BFA from Illinois Wesleyan University in 1984. She has recently pursued graduate studies in sociology and anthropology at the University of Chicago. McGinnis is regularly selected to show her work in juried exhibitions, most often in the Soho district of New York City. Awards received by the artist include: Grumbacher Award 1984, National Bronze Award, Broadcast Designers Assoc 1987, and a national Television Emmy Award for Design, 1991. Her current series of allegorical paintings communicate humanity's concerns on a metaphysical level. They are gentle warnings to humanity and speak visually about our people, times, triumphs and hopes, and how these conditions consistently coexist.

The painting shown in the 10th Edition is the artist as a black woman residing in that gray area between black and white, the gray area being a place of compromise, riches and peace.

Price range of original work: $1000 - $6000.

2654 W Medill Ave #308, Chicago, IL 60647-3019 312·227·0702
www.artscope.com

Represented by ARC Gallery, 1040 W Huron St, Chicago, IL 60622 312·733·2787

JULIE McGUIRE

5 *My Corinthian Capitals Always Look Like Pineapples*
 Acrylic on canvas, 24x30". Artist's collection.

Julie McGuire is a doctoral candidate at Indiana University where she is completing her dissertation on the performance art of Laurie Anderson. Presently she teaches art history at Georgia Southern Univesity at Statesboro, Georgia.

McGuire's artwork, whether painting, sculpture or installation, combines a broad range of interests. Historical, anthropological, as well as archeological subjects mix and mingle with popular culture and autobiographical information.

Price range of original work: $600 - $2000.

310 Clairborne Ave, Statesboro, GA 30458

GRACE MERJANIAN

91 *Tea Time*
 Watercolor, 18½x24". Artist's collection.

91 *Light House*
 Watercolor, 29x15". Artist's collection.

Grace Merjanian's jewel-like paintings are infused with an agile magic. Filled with an intoxicating joie-de-vivre, her landscape paintings glow with romantic images of a serene dream world. Her exotic paths to gazebos, enchanting gardens and ethereal shorelines lead the viewer to mysterious distant lands, yet her work has a beckoning warmth, rich with familiarity and nostalgia. Beyond visual worlds of blissful escape, they serve as mental retreats for viewers and collectors of her work.

Painting in oil and watercolor with gouache, Merjanian's extensive travels serve as inspiration for her subjects. She enjoys teaching art classes, giving workshops, and demonstrating her painting techniques for local art leagues.

Her representational style has afforded her many awards. She is

represented in collections throughout the United States, Germany, France, Canada, South America, South Africa and Lebanon. Her work is currently on view at the Framewright Gallery in Huntington Beach, CA. Limited edition prints of her work are available.

Price range of original work: $75 - $3500.

18701 Deodar St, Fountain Valley, CA 92708 714·968·5983

DEANNIE MEYER

55 *Tired Out*
 Watercolor, 39½x31½". Artist's collection.

Deannie Meyer received a BFA from California College of Arts & Crafts in Oakland, CA. She has won awards for her watercolors and has shown her work in various parts of the United States. Her work consists of realistic portraits and still-lifes with an abstract quality, although maintained within the boundaries of realism. "My art is about contrasts, both real and imagined. The quality of light in California inspires me to portray the contrasts I see in life. Although I am a realist painter, I find fascination in abstractions." Meyer works both in watercolor on paper and oils on canvas and wood.

Price range of original work: $500 - $2500.

1377 Dominion Dr, Redding, CA 96002 916·222·6865

FRANCES MIDDENDORF

107 *The Beach*
 Gouache and ink, 6x17".

Frances Middendorf received a BFA at the Rhode Island School of Design in 1982. She then went on for a MFA at the School of Visual Arts in New York City. She is an award-winning illustrator who has worked for Merrill Lynch, Johnson & Johnson, *Newsweek* and the *New York Times*, among others.

"I'm excited by black lines and how they illuminate color, as in stained glass. Like an ideogram in Eastern Calligraphy, the black lines edit the form and are a language in themselves."

The Beach was a seasonal assignment for a Merrill Lynch publication. "I approach assignments as an opportunity to exercise formal skills. In *The Beach*, I was most challenged and inspired by the aerial perspective and the color interaction."

Frances Middendorf's work has been shown at the Marine Museum of Fall River, MA and in group shows in Los Angeles and New York City. She is now shown exclusively at the Silverwood Gallery on Vashon Island near Seattle, Washington.

Price range of original work: $300 - $1000.

337 E 22nd St #2, New York, NY 10010

212·473·3586 Telephone/Fax E-mail: juxo@aol.com
Represented by *Silverwood Gallery*, 24927 Vashon Highway SW, Burton, WA 98013 800·536·8287 206·463·1722

DENIS MILHOMME

70 *Dawn Over the Desert*
 Oil, 20x30". Private collection.

After extracting all of the art knowledge he could from his local college, Denis Milhomme attended workshops and symposiums given by world renown artists. In 1983 he became a full-time artist. In the ensuing years he has been fortunate to receive many awards, among them the 1993 Arts for the Park Regional Winner, as well as many best of shows, people's choice and purchase awards. With his use of detail he hopes to impart to his viewers his love of nature and the beauty of the desert southwest. Through the use of oil paints he hopes to bring to all who view his art the sensation of actually being there to feel his joy and awe at seeing a beautiful sunset, or the magnificence of an early morning sunrise. Milhomme takes many trips to exotic desert locations to record the enchantment. In the studio, he again feels that excitement as he paints the reenactment of his safaris into delight. The reward he feels for the joy his paintings give his viewers is beyond measure.

Price range of original work: $395 - $5000.

PO Box 988, Three Rivers, CA 93271-0988 209·561·3244

ALEX MIZUNO

74 *Greetings from Egypt*
 Pastel, 22x15". Private collection.

Alex Mizuno was born in Japan. His artistic talent was first acknowledged when he won a prize in a national political campaign poster contest at the age of ten. After he worked as a production artist on a French-Japanese film, "Collections Privées," he moved to the United States and refined his talent as a commercial artist. Working as illustrator and designer, he has created album covers and posters for plays and concerts. His recent work include book illustrations for Simon & Schuster and computer animation for MacroMedia Software.

For the past eight years, he has been responsible for stage design and street decoration for San Francisco's largest outdoor festival, the Cherry Blossom Festival.

Price range of original work: $500 - $2000.

140 Harold Ave, San Francisco, CA 94112
415·239·4886 Telephone/Fax

CRYSTAL MOLL

105 *Springs' Green 1996*
 Oil on canvas, 41x20". Artist's collection.

Crystal Moll received her BFA from Moore College of Art in Philadelphia. Now living in Baltimore, she uses street scenes throughout Maryland and Virginia as the subject for these 'sun

Red Sky by Michelle Angers

struck' urban landscapes. Working only on location, she chooses her subjects for how they are affected by the light of a particular time of day and season. The process begins with a sketch in order to develop the composition. She then makes several visits to the site enabling her to explore and interpret the effect of sunlight on the scene.

These urban landscapes have been exhibited in galleries throughout PA, MD, DC, VA, and GA. Collections include the Albert V Bryan Courthouse, Alexandria, VA; the Marsh McLellan Building, Baltimore, MD; Rohm and Haas Co, Philadelphia, PA; and Berkowitz and Assoc, Baltimore, MD.

Price range of original work: $1000 - $5000.

217 Mariners Point Dr, Baltimore, MD 21220 410·391·3166 410·837·3621 Fax

ROSEMARY MORISON

122 *Hebe and Ganymede, Cup-Bearers to the Gods*
Watercolor, 29x21".
Private collection.

Rosemary Morison has a Fine Arts Degree from Liverpool University, England. She has shown extensively in both Canada and Europe. At present she is working on three solo shows in England.

An extensive period of studying watercolor has produced a profoundly individual technique—as many as twenty glazes applied over a detailed drawing produce some fascinating results.

In her statement Morison explains her work. "My style of work evolves from an inherent interest in form and color plus a taste for allegorical/narrative art. My love, affection and delight in the absurdity of the human condition gives me carte blanche to place people and personalities from my experience into environments of my choosing."

Hebe and Ganymede, Cup-Bearers to the Gods is a pastiche that pays tribute to her muse—a contemporary Hebe and Ganymede bear cups for their own particular Gods in a magnificent Italian Garden that enhances a Chicago temple.

Price range of original work: $1000 - $2000.

1147 W 8th Ave, Vancouver, BC Canada V6H 1C5 604·736·1939 1704·568676 (U.K.)

KRISTINA MUHIC

138 *Questioning Life*
Pastel, 30x22". Artist's collection.

Kristina Muhic is a fifth-generation San Franciscan. She received a BA in studio art from Humboldt State University in California in 1988. She has continued to pursue her artistic career as a painter and illustrator in Marin County, CA, exhibiting her work in the bay area, teaching art to children, and illustrating children's books. Muhic is influenced and inspired by the trails, woods, ocean and living creatures of the West Coast. She gains spiritual strength through their beauty, which she is compelled to convey through her art. Her style leans toward stylistic, illustrative designs that have flowing lines and bright, contrasting colors. She works in acrylic, pastel, colored pencil, ink and print making.

Price range of original work: $150 - $1000.

Box 497, Lagunitas, CA 94938 415·488·9395

JULIE K NEVA

48 *The Lovers*
Acrylic and ink on canvas, 42x44". Private collection.

48 *Riomaggiore*
Acrylic and wax on canvas, 42x32". Artist's collection.

Julie K Neva's art strives for innovation and visual poetry. Each painting tells a story for the viewer to conceive. This approach of engaging the viewer in an activity gives depth to the body of work she has created. The compositions, rich in color and texture, start with stretched canvas and take on a life through varying mixed media—wax, acrylics, charcoal, image transfer, photography and words.

Currently, forty-two of Neva's pieces illustrate an artist's book, *Halcyone*. *Halcyone* is a love story paralleled to the creation of the universe through sequences of individual prose with a color reproduction.

"Expressive satisfaction means something to our lives. Perhaps time may slip away for a moment and when we return we will have learned something."

Books, paintings and special projects are available from the artist.

Price range of original pieces: $1,000 - $5000.

34081 Pequito Dr, Dana Point, CA 92629 714·248·0157

Universe in a Pot by Erik Bright

JOELA NITZBERG

96 *Homeless*
Oil, 30x40". Artist's collection.

Joela Nitzberg has a BFA from Boston U. Her work is shown locally and may be found in many private collections.

Her realistic paintings are based on her emotional response to many and varied subjects. Nitzberg has specialized in animal portraiture for many years. Her deep love for animals has enabled her to put their individuality and loving hearts on canvas. This has brought great joy to the owners who have commissioned her work.

She has recently begun private teaching in her studio and is finding it a fascinating and fulfilling experience.

"Subject matter is relatively unimportant to me. The need to create a moment in time, a memory or a feeling is always dictated by a very intimate visual experience. To share part of myself is the

ultimate goal of any picture I create. In this world of separation where one is always searching for a connecting source of fulfillment, it is my hope that what I paint may in some way help to bridge the gap."

Price range of original work: $500 - $5000.

16347 Royal Hills Dr, Encino, CA 91316 818·981·0410

SYLVIA OBERT-TURNER

54 *Tres Flores*
Oil on masonite, 8½x6½".

PO Box 1087, Cochise, AZ 85606 520·384·3061

MARCELLE HARWELL PACHNOWSKI

79 *El Diablo y San Antonio*
Oil, 36x43". Artist's collection.

79 *Night into Dawn-Moorea*
Oil, 36x43". Artist's collection.

Marcelle Harwell Pachnowski holds her MFA from the University of Maryland and her BA from the American University in Washington, DC. She has been a working artist for more than two decades and exhibits both nationally and internationally. Her work can be found in numerous private and public collections in the U.S. and Europe.

Influences from Pre-Columbian cultures, travels to Mexico, and French Polynesia have created expressionistic images through conscious and unconscious dreams that have infiltrated her painting. Her creative ability is channeled by music. The power and attraction of music is a major catalyst causing a semiconscious flow of movement, feelings and energy. The result is the creation of art that is fed from musical, ethereal, political, private/personal, and external forces that permeate her painting.

Pachnowski has also been teaching for the last 25 years in various venues from preschool through college, including a variety of at-risk populations (i.e. homeless, incarcerated, seniors, emotionally, mentally and physically disabled). This too has made a profound influence on her work.

Price range of original work: $1200 - $2600.

222 Hicks St #2C, Brooklyn, NY 11201 718·858·6512

PEGGY PALLETTI

72 *Alchemy*
Oil pastel on banana bark with metal pieces, 25x38". Artist's collection.

123 *That's Me*
Oil pastel on paper 14x11". Artist's collection.

Peggy Palletti was born in Chicago in 1963 and grew up in Germany. She started painting with lipstick and nail polish. The more she utilized her artistic abilities, the more she discovered herself painting faces, eyes and lips. When she returned to the United States in 1992, she discovered gourds, and started creating three dimensional art. The faces that she paints or burns into the gourds appear to her at night before she falls asleep. With her art she expresses feelings and thoughts of many kinds, ranging from very personal to social, political, psychological and philosophical. She wants people to think in a new and different way. She feels that the eyes and faces especially teach and talk—the eyes being the gate to the soul. "The more a person is open to the spiritual and physical world, the deeper one can see."

Sea Elegance by Yali Peng

Price range of original work: $250 - $5000.

1429 Hemlock, Napa, CA 94559 707·255·9211

CHRISTIANE PAPE

97 *Barcone*
Mixed media, 40x44". Private collection.

97 *Arizona*
Acrylic on canvas, 30x34". Private collection.

Christiane Papé was born in Geneva where she grew up and completed her studies.

Having lived and travelled extensively in Europe and the U.S., always accompanied by an innate, acute sense of observation, she adeptly transmits through her work on canvas a vision of things both original and personal.

Papé is a lover of nature, and she impregnates her works with that love. She is as much at ease with her famous exotic floral compositions as with her abstracts, where one perceives natural elements which go far beyond a strictly visual sensation. Her canvases profoundly touch and intrigue the spectator in an intensely pleasant manner. Having always been an avant-garde painter and after years of searching and exploring, her work faithfully reflects forceful energy and aggressiveness well mastered.

Her latest compositions in acrylic mark a decisive point in Christiane's career. With a style at times audacious yet refined, she has proven her mastery in the application of color through which tantalizing mirages captivate the viewer. Papé has seduced a vast public in Europe and The United States. Her paintings are represented in major public and private collections in Rome, Milan, Genova, Paris, Geneva, London and New York, where she presently lives.

Price range of original work: $2000 - $10,000.

500 E 77th St #907, New York, NY 10162-0014 212·472·9602 212·861·7324 Fax E-mail: ezwed@aol.com
http://www.liqwwwd.com/montague/pape/exhibit.htm

LEE PARK

72 *Let Me See*
 Mixed media, 18x24". Artist's collection.

From 1962 to 1981 Lee Park had several private shows in Korea and abroad. In 1982 he moved to the United States and held a private exhibition at Modern Art Gallery in Los Angeles. Since then he has shown at Olympic Art Gallery and Cosmos Art

Magnetically Distorted City by Robert F Kauffmann

Gallery in Honolulu. His paintings were successfully auctioned at the Christian Children's Fund Auction, which many celebrities attended. In 1987 he was invited to Seoul, Korea, for the 8th Annual Korean Art Culture Festival, as the Korean-American artist.
He has been working to create a nontraditional style by painting very colorful and contemporary paintings using materials such as rice appear, hardboard and Chinese silk, intermingling Oriental and Western art.
Recent Exhibits:
1995 '95 Invitational Exhibition of Korean Contemporary Fine Art at Bridgeport University in New York
1993 Asia Invitation Art Exhibition in Seoul, Korea, Metropolitan Museum of Art
1993 La Peintre Moderne de Coreene '93 La Premier Exposition a la Galerie Galam, Paris, France
Price range of original work: $16,000 - $20,000.
1935 S La Salle Ave #31, Los Angeles, CA 90018 213·735·1778

JOHN V PARTRIDGE

90 *American Pride*
 Watercolor, 20x27". Artist's collection.
90 *Where Liberty Abides*
 Watercolor, 30x24".

A native Californian and self-taught artist, John V Partridge simply enjoys watercolor painting. Although he specializes in landscapes accented with architectural designs, he paints almost anything imaginable. His previous success in the automotive industry has helped him in the marketing strategy and building of his fine art business.
Partridge is also a noted designer of magazine covers for local publications and does a considerable amount of commissioned watercolor paintings. Commissioned work can be completed from photographs provided to the artist. To assist with questions, a full-color brochure and order form is available on request.
In 1996 Partridge will be publishing a series of three different prints, each in a limited edition of 750, signed and numbered—two of which are exhibited in this book.
Price range of original work: $500 - $1500.
PO Box 1893, Paso Robles, CA 93447 805·238·3393
805·238·4201 Fax

MARK PELNAR

93 *Still Life with Drawings #1*
 Oil, 27 1/4x48". Private collection.

Mark Pelnar received a MFA from Tufts U and the School of the Museum of Fine Arts, Boston. He has won several awards in national juried shows and exhibits regularly in national competitions.
His compositions are constructed from many different source materials and are used so that two different levels of illusion coexist in a single image. One level is the illusion of actual objects and another is the illusion of renditions of the artist's previous drawings; subjects that are already imaginary. The intent is to create for the viewer a rich and varied visual experience. His painting style is one of hard-edged clarity, with an emphasis on textural detail.
Most of the subjects used in the paintings are of a common, everyday nature. An inventive and well-executed interior focuses attention on what we consider too unimportant to notice. This lavishing of attention on the overlooked aspects of everyday life can awaken one's vision to the richness and beauty to be found there, and present common objects as something fresh, as if seen for the first time.
Price range of original work: $700 - $3500.
4148 Vernon, Brookfield, IL 60513 708·485·6078

YALI PENG

131 *Sea Elegance*
 Photograph. Artist's collection.

Yali Peng is currently in the Master of Liberal Studies program at the University of Minnesota, focusing on art and healing.
Her self-teaching and participating in art workshops across the U.S. made her start exhibiting and teaching coiled basketry, sculpture (fiber, illuminated, mixed-media), and photography since 1994. She has won some awards and publication for her photography. Her works are included in many private and corporate collections.
The most unique point about her art is that she converts certain energy—music, sound, light, movement—or images from films,

plays and literature into a three-dimensional form of art—she considers her ink painting as three-dimensional—or captures and freezes the moment as visual poetry using photography.

Her art philosophy is the reflection of practicing Nichiren Daishonin's Buddhism.

Price range of original work: $50 - $400.

1400 S Second St #B302, Minneapolis, MN 55454
612·722·8326 Telephone/Fax

FERN L PHILLIPS

51 *Morning Light*
 Oil on canvas, 36x48". Artist's collection.

Fern L Phillips was born and raised in Montana. As a natural result of these roots, she has a strong kinship to nature and wildlife. Seeing wildlife diminish on open spaces and disappear over the last 20 years, has added to her desire to depict these areas in oils, with a hope that the trend toward wildlife destruction will diminish and a conservation of these natural places will begin in earnest. Phillips has a BFA with distinction from California State U at Long Beach. Her art work has earned many awards, among them a first place in a statewide painting competition in Sacramento and a purchase award in painting. She has displayed her artwork in shows from California to New York. Her paintings are found in many collections throughout California.

She strives to depict the nobility of the species or area she is painting using a high palette, interesting textures and moving compositions.

Price range of original work: $1500 - $2000.

13791 Hawthorne Blvd, Hawthorne, CA 90250-7016
714·898·8006 310·676·1732 Fax E-mail: JFPhil@ix.netcom.com

Aqua Serpentina by Sy Rosenwasser

HUGH POLDER

25 *Bark Wonderer*
 Casein, 18x24". Artist's collection.
25 *1931 Thompson*
 Casein, 18x23". Artist's collection.

Award winning artist, Hugh Polder attended the Central Academy of Commercial Art, and Gephart School of Portrait Painting.

He enlisted in the Air Force in '51-'54 as illustrator for the 3300th Publication Unit Air Training Command, St Louis, MO. After leaving the service he became a commercial artist for studios and agencies. He started free-lancing in the mid-60s, illustrating catalogs, books, magazines and calendars. He now specializes in historical aviation and marine art.

Polder has donated paintings to the National Museum of Naval Aviation, the Air Force Art Program and the Experimental Aircraft Museum. His work is also exhibited at the San Diego Historical Center and SimuFlite Center, Dallas/Ft Worth Airport. Prints and originals are exhibited around the country.

He has lived in Chicago for the last 40 years and is a member of the US Naval Institute and American Society of Aviation Artists.

Price range of original work: $1000 - $10,000.

3540 W Beach Ave, Chicago, IL 60651-2201 312·772·7683

GAYLE PRITCHARD

3 *Masks II: The Joybringer*
 Fiber, 23x33". Artist's collection.

Gayle Pritchard's fiber pieces include small, intimate collages, sculptures and small to gigantic wall quilts. Because her work is conceived to be experienced and enjoyed on a personal level, she creates an immediate connection to the viewer through the familiarity of the materials used. Once the viewer is engaged, the textural sensuousness of Pritchard's surface techniques invites a closer look at the deeper issues explored in her work.

Selected regional exhibitions include: Ohio Designer Craftsman's, The Cleveland Museum of Art and the Canton Art Institute. Her work has been exhibited in Denmark, Japan, Australia, and in Washington, DC, Los Angeles, San Diego, as well as many other cities nationwide.

A Christmas ornament commissioned by the White House in 1993 is part of the Smithsonian collection. In additional to several television interviews, her artwork has been published in numerous national magazines and in Japan.

She was recognized by The Professional Quilter as a Teacher of the Year in 1989.

Price range of original work: $50 - $4000.

31001 Carlton Dr, Bay Village, OH 44140
216·871·9865 Telephone/Fax E-mail: fv772@cleveland.freenet.edu

BARBARA RACHKO

23 *He Lost His Chance to Flee*
 Pastel on sandpaper, 58x38". Artist's collection.

Barbara Rachko was born in Paterson, NJ in 1953. She received her BA from the University of Vermont and has studied at the New York Academy of Art, Georgetown University and the University

of Maryland. Her work has won dozens of awards.

The "Domestic Threats" series of pastel paintings and related photographs uses cultural objects—Mexican masks, carved wooden animals, papier mâché figures, and children's toys—in a lively blend of reality and fantasy. Rachko uses these objects not only as surrogates for human actors, but as potent symbols: a heady amalgam of childhood memories, half-forgotten dreams and images encountered in diverse sources such as magic realist literature, mythology, cultural anthropology, trips to Mexico, science fiction movies and TV programs from the 60s and 70s. The imagery demands to be studied at length. Evident here is a new type of realism into which the real enters, not as the total substance, but merely as one element.

Price range of original work: $275 - $10,000.

1311 W Braddock Rd, Alexandria, VA 22302-2705 703·998·7496
703·683·5786 Fax E-mail: brachko@worldweb.net

Jammin by Pati Kent

TANYA RAGIR

125 *Cradle #2*
Painted resin, 26x10". Private collection.

Tanya Ragir is a native of California, receiving her BA from the University of California at Santa Cruz. As a sculptor, she works in the realist tradition and has the female form as her chosen subject. Her aim is to create the dynamics of movement. Her figures are fluid and fragmented. They are conceived and assembled in terms of rhythm and external lines, shapes and mass. The ability to present an involuntary medium as an essential fluid form is the sum of her achievements.

She recently received an award from NASE for her figurative sculpture. Solo exhibitions include the Burbank Contemporary Art Center, the Total Art Museum and the Hundai Gallery in Seoul, Korea.

Price range of original work: $800 - $25,000.

3587 Ocean View Ave, Los Angeles, CA 90066-1909
310·398·6004 310·398·7965 Fax

ENNIO ROMANO

77 *Solitude*
Oil on canvas, 36x36".

Ennio Romano received his art training at Citrus College in California. He graduated from the University of California with a degree in Fine Art. He is presently a professor of Human Anatomy at the California Academy of Art.

Romano paints predominantly in oil, but also is proficient in many other media, including watercolor and acrylic. His work is collected in many countries, has appeared in newspapers and has been exhibited in several major galleries.

He does many paintings of landscape, in the typical style of California. A luxurious portfolio of paintings of Italy shows his love for that country. He has had several successful exhibitions and has had his paintings purchased for numerous private collections in the United States, Central America and Italy. He is the winner of Gran Targa Leone di S. Marco, Venice Biennale International Art Exhibition 1995, the most prestigious Italian show of international contemporary art.

Price range of original work: $1000 - $10,000.

via di Chianciano 25, 53047 Sarteano, Siena, Italy
0578·266·639 Telephone/Fax

SY ROSENWASSER

133 *Aqua Serpentina*
Bronze and patina, 10x6x4'.

Sy Rosenwasser have been sculpting for over thirty years along with his practice as a Urologist. Having lived most of his adult life as a physician dealing with and solving pressing matters concerning life and death, his art experiences have given him an opportunity to express his emotions in a nonverbal way. He tries to convey feelings about the interrelationships between men and women. His feeling for the closeness and unity of family is another theme that has evolved from his experience working with families as they deal with their loved ones' health matters. Flight is a motif he uses to express the desire to escape from life's pressure. The concept of hope comes in to play with the feeling that there is a higher power that can be found for the solution of some of life's problems. To complete these emotional and spiritual aspects of his art, Rosenwasser contributes a feeling of warmth by the addition of a polished surface that yearns to be touched and colors that visually tantalize the eyes. His sculpture combines the relationship of winged flight and the life force of water and its continuing renewal.

Price range of original work: $3000 - $110,000.

1260 15th St #1101, Santa Monica, CA 90404-1135
310·393·7369 310·476·3466 Fax

JENNIFER ROTHSCHILD

58 *Football Hero and Fan*
 Watercolor, 25x19". Artist's collection.

Having made Oahu her permanent home, Jennifer Rothschild has found the colors and textures of island themes a natural choice for her painting style. Watercolor is a medium that the artist has always found to be a favorite choice in her work. Recently she has added acrylic and mixed media, working on a three-dimensional technique that extends the forms and shapes to create sculptural depth.

In 1995 two of Rothschild's floral paintings were selected by the National Easter Seals Society for the 1996 Easter Seals. Rothschild's graphic design was picked for the 1995 Hawaiian Pacific Tennis Association Yearbook cover. Her work was shown in the open exhibit of the H.W.S. 33rd Annual show and at the first Black and White exhibit held at Honolulu Hale City Hall.

Rothschild was awarded a scholarship to Choinard Art Institute and the Art Center in Pasadena. She received her BA at California State University Long Beach in art education.

Rothschild is a member of the Hawaii Watercolor Society and is on the board of the Association of Hawaii Artists for 1996.

Price range of original work: $350 - $2000.

17 Moloa'a St, Honolulu, HI 96825 808·395·3238
808·395·5334 Fax

MANABU SAKAGUCHI

33 *Sweet Sounds*
 Acrylic on canvas, 24x51". Artist's collection.

33 *Misty*
 Acrylic on canvas, 35x57". Artist's collection.

A copywriter friend of Manabu Sakaguchi, upon seeing his works, named them "mindscape paintings."

"If the scene depicted on the canvas of my mind can accumulate a past and future over a long period of time....the sweet flow of time transfigures an instant into a whole story in itself, hinting at the preceding and succeeding times. When drifting into that temporal-spacial region, I am depicting each story...of people clinging to the past or rushing into the future. At that time, I am a poet of time."

The title of each composition is the prologue to each story.

Price range of original work: $1000 - $19,000.

5-11-18-605 Shinjuku, Shinjuku-ku Tokyo 160 Japan
81·3·3356·4108 81·3·3357·2416 Fax

DOUG SCOTT

88 *Happy Trails (Roy Rogers and Dale Evans)*
 Colorado marble, Lifesize.

89 *Roy Rogers*
 Colorado marble, Lifesize.

Doug Scott began wildlife carving while in the fourth grade. In 1972 Scott's first professional artwork was sold.

Today, in a quiet studio near Taos, New Mexico, he sculpts about 20 new pieces each year. Although the artist works in wood and metal, his favorite materials are hard stones—onyx, rhodonite, serpentine, marble and granite. Unlike the majority of stone sculpted today, diamond cutters and abrasives have to be used on all of Scott's hard-stone sculpture. More than 325 pieces have been completed to date. The largest of his monumental commissions is a 20-foot sculpture for Wildlife West of Edgewood, New Mexico. Editions available.

Price range of original work: $3000 - $150,000.

Rt 1 Box 26, Taos, NM 87571-9500 505·758·4722

PHILIP SHERROD

8 *Ms. Ricco..Goes-To..(MANHATTAN!)?*
 Oil on canvas, 80½ x60½". Artist's collection.

1996, 1995, 1983 American Academy of Arts & Letters, Invitational Awards Exhibitions, NY
1996, 1988, 1981 Adolph/Esther Gottlieb Foundation Grant, NY
1995 First International Art Biennale of Malta, Juried
1995 Museum of City of New York, New York Now Cityscapes
1995 National Academy of Design, Collection Update, NY
1996-1984 Art Student League, instructors and exhibitions, NY
1995-1993 National Academy of Design, 170th Annual Exhibition, NY
1995 Lakin-Jones Gallery, One person exhibition, Omaha, NE
1994 Korea Times, A 20th Century Expressionist, article
1994 Penthouse Magazine, March Issue
1994 Federation of Modern Painters & Sculptors, Fordham U
1989 Smithsonian Institute, Hirshhorn Museum & Sculpture Garden, New Acquisitions-Exhibitions
1989 Pollock Krasner Foundation Grant
1983, 1976, 1973 Allan Stone Gallery, Solo exhibit, NY
1982 National Endowment for the Arts Grant
1980 Creative Artists Public Service Foundation, CAPS grant.

Price range of original work: $200,000.

41 W 24th St, New York, NY 10010 212·989·3174
Represented by *Allan Stone Gallery*, 113 E 90th St, New York, NY 10128

Les Baux by Carol Bernard

YVETTE SIKORSKY

16 *Maui*
 Acrylic, 36x48". Artist's collection.
16 *Flotilla*
 Acrylic, 36x48". Artist's collection.

Exhibitions:
1996 ArtExpo, Jacob Javitts, New York
1995-1993 Abney Gallery, Soho, New York
1992 Montserrat Gallery, Soho, NY
1992 Ariel Gallery, Soho, NY
1991 Winner at Ariel Gallery Competition
1990 Morin Miller Gallery, NY
1990 ArtExpo, NY
1990 Agora Gallery, CT

Superimposed Bridges by Patricia Hausmann

1989 Ariel Gallery, NY
Awards include the Manhattan International Award of Excellence and Soho International Art Competition Certificate of Excellence in 1993.
Sikorsky is seeking work on commission from consultants and interior designers.
PO Box 146, Lake Mohegan, NY 10547-0146 914·737·5167

LIDIA SIMEONOVA

75 *I'm Butterfly, You Are...*
 Acrylic, 42x24". Artist's collection.

Lidia Simeonova graduated from the University of Fine Arts, Bulgaria. Memorable performances at international exhibitions and contests brought her several awards among which are: First prize for contemporary art at Chatellerault Salon for Fine Arts, France; Diploma from the International contest in Venice, Italy; Award of Merit from Douglaston Exhibition Salon, NY; Honors from the *Artist's Magazine* Competition '95.
Simeonova's acrylic paintings on canvas and paper are aesthetically influenced by the European tradition. Fine touches of color and shape expressively convey the intricacy of human emotion. Modernism and reality intermingled in an unison are the essence of her provocative yet universally accepted imagery. Exquisite techniques of blended colors and materials further enhance the beauty of her works.
Her honors include participations in national exhibitions of San Bernardino Art Museum, California; Rodger Lapelle Gallery, Fedulov Gallery and Medici Center for Visual Arts, Philadelphia; Arts Center of the Ozarks, Arkansas, as well as memberships in Bild Kunst Artistic Society, Germany and National Association of Women Artists, U.S.

Price range of original work: $500 - $2000.

24575 Greenhill Rd, Warren, MI 48091-1675 810·758·0468
Represented by *Albena Tzonev*, 2973 N Seaton Circuit, Warren, MI 48091 810·755·8610

MARK T SMITH

Back cover *The Annunciation of the Virgin Mary (Insert God Here)*
 Mixed media, 30x12". Artist's collection.

Mark T Smith graduated from Pratt Institute in Brooklyn, NY in 1990 with a BFA. His painting on the back cover of this 10th Edition is one of the most recent paintings created in an ongoing series. *Insert God Here* contains many common elements found in Smith's work, such as satire and wild iconography. The piece represents the most current trends in the artist's work, the de-evolution of representational forms into an abstract language.
His patrons include Walt Disney Company, MTV Networks, Showtime Networks, Nickelodeon, McMillan and Harper-Collins Publishers. His most recent commission was the Spring 1996 campaign for Absolut Vodka entitled Absolut Smith.
Smith has participated in numerous group and solo shows throughout the country. He had a solo show at the E3 Gallery in New York City in 1996. In addition, Smith will be participating in a group show of small works at Parsons School of Design in NY where he teaches drawing and painting in the Illustration Department.

Price range of original work: $250 - $7500.

212·679·9485

TIMOTHY STAFFORD

31 *Jelly Bean Pool*
 Airbrush, 24x22". Private collection.

Timothy Stafford has had his work shown in many juried exhibitions and publications. Self-trained in airbrush, he has worked almost exclusively with that medium.
While developing his technique he found he could subtly apply many different layers of color in order to achieve the right look and feel for his work. Since completing his degree in fine art he has continued to develop his style incorporating some kind of illusion or twist and trying to show a lighter side of art.
Stafford is now expanding his mediums to include the computer. He is fascinated by the visual potential the computer lends to his creativity. He has recently been using it as a tool to digitally

conceptualize his ideas.
Among the awards he has won are Fourth Place in the Fine Art Category of the *Airbrush Action's* Tenth Annual Airbrush Excellence Competition, First place in the Fine Art Category of the 1996 *Air Storm* Competition, and the Grand "Crabbie" in the second *Art Calendar* National "Crabbie' awards.

Price range of original work: $300 - $1200.

926 Hudson St, Hoboken, NJ 07030 201·459·1501

R M SUSSEX

100 *Morning Paper*
 Oil, 16x20". Artist's collection.

RM Sussex works in oils, painting landscapes, florals and people. Her work reflects the influence of the French and early American Impressionists.

Sussex' has exhibited her oils in galleries in the Northwest, New York, California and Japan. The artist's works are in private and corporate collections throughout the United States, Japan and Canada. Photographs of her paintings are available on request.

Price range of original work: $500 - $3000.

2005 S Fairway Dr, Pocatello, ID 83201-2354 208·237·3396
208·232·2178

GLORY TACHEENIE-CAMPOY

4 *Untitled*
 Acrylic on canvas, 36x24". Artist's collection.

Glory Tacheenie-Campoy paints, sculpts and weaves. She has earned awards in juried competitions. Her work is in private collections nationwide.

The artist is Dine (Navajo), from Cedar Ridge, AZ where she learned the traditional art of textile weaving. She learned to respect and appreciate the beauty and power of the Earth. Her work is an expression of two cultures in conflict. "There is no word for art in Navajo, since art is inseparable from language, religion, government, education, life, etc..."

Tacheenie-Campoy investigates innovative ways of incorporating color and form into paintings and sculptures. She experiments with a variety of materials ."Images in my work include cars and trucks, flowers, horses, landscapes, and geometric shapes to portray the struggles and successes of Native Americans. Flowers are usually a metaphor for the Earth. Bright colors are necessary as symbols of hope—even in the most terrible circumstances there is hope."

Price range of original work: $400 - $6000.

PO Box 85786, Tucson, AZ 85754-5786 520·743·9769

FRANK TAIRA

85 *Alone*
 Oil, 20x18". Artist's collection.

85 *Black Bridge*
 Oil, 32x36". Private collection.

Frank Taira was born in San Francisco in 1913. He studied painting and drawing at California School of Fine Arts from 1935-1938. He exhibited at the San Francisco Museum of Art in 1940. He then moved to New York to continue his art studies and exhibitions. In 1956 he studied at the Art Student's League. In 1957 he studied painting materials and techniques under instructor Ralph Mayer at Columbia University. He then experimented with different styles and techniques of painting.

Taira has exhibited in national juried exhibitions such as: Audubon Artists, Knickerbocker Artists, Allied Artists of America, National Academy of Design and more. In 1968 he had a one-man show sponsored by Emily Lowe Foundation; in 1980 a one-man show sponsored by Caraban House Gallery; in 1992 a one-man show sponsored by Grazoli Gallery. He received the Robert Philipp Award from Audubon Artists. He is listed in *Who's Who in American Art*. He is a member of New York Artist's Equity.

Price range of original work: $500 - $5000.

135 W 106th St #3Y, New York, NY 10025-3752 212·663·4546

JOANNE TURNEY

144 *Grace*
 Acrylic, 71x51".

Joanne Turney exhibits in New York and Pennsylvania. She paints in the affirmative mode. "I choose to express the positive side of the coin. I paint below the surface, what is not seen but felt—the beauty, harmony, energy and joy that surrounds and enfolds us." The spirit of affirmation permeates all her paintings, filling the viewer with an appreciation for poetry and the wild force of nature. It's raw untrampeled beauty. The rich array of greens attest to her love of the landscape, although no overt landscape element appears.

Price range of original work: $500 - $4000.

PO Box 201, Swarthmore, PA 19081-0201 610·544·3077

FAITH TYLER

117 *Red Tile Floor*
 Pastel, 20x13". Private collection.

Faith Tyler's fascination with light and illumination grew out of her years of experience painting and drawing Buddhist iconography. Figures in the Buddhist pantheon are often painted surrounded by light emanations to express inner radiance. For her, that sensibility has gradually carried over to simple objects: chairs, windows, a bowl, emanating light to express a charged, energetic quality, or kinetic aliveness.

In this piece *Red Tile Floor*, the somber, lonely quality of one chair in a spare, austere room, is balanced and soothed by the radiance of the scene. "I think everything is alive, dancing some kind of wild, intelligent, atomic fandango."

Tyler received a BA in Art with honors from California State University at Los Angeles. She has designed the interior of an automobile showroom and illustrated for different publications, including *Yoga Journal*. Her paintings are represented in private collections worldwide. Among her corporate collectors are Microstrategies and Hewlett Packard.

Price range of original work: $175 - $2000.

1644 Francisco St, Berkeley, CA 94703-1217 510·644·0669

Questioning Life by Kristina Muhic

JON VAN BRUNT

67 *Love Seat*
Oil on canvas, 47x42". Artist's collection.

Jon Van Brunt is a native New Yorker. He holds a BFA in print making from Maine College of Art and an MFA in painting from Ohio University, where he taught two-dimensional design. He has exhibited throughout New York. His work can be seen on Art Communication International's permanent CD-rom collection. He works in all mediums, but prefers oil on canvas or wood, often integrating elements of photography or sculpture into the painted pieces. His approach to painting is intuitive, using whatever tool it takes to apply the paint or take it away.

His work comes from observation and memory, usually in that order. He takes mental notes or quick sketches of subjects that he finds interesting—in the case of *Love Seat*, an old chair at a yard sale, and lets them develop in the studio. Each painting is a frame of a filmstrip and represents a moment in time. He demands total control of the painting and thereby maintains a dialogue with the work during each session, which can last from twenty minutes to two weeks.

Price range of original work: $1500 - $2000.

216 Putnam Ave, Freeport, NY 11520-1141 516·378·5097

GEORGE ALPHONSO WALKER

7 *Heaven and Earthly Watch*
Oil, 28x22". Artist's collection.

George Alphonso Walker was reintroduced to earth on February 19, 1962 in the tropical island of Jamaica. He was educated at Fashion Institute of Technology in New York in Fine Arts in 1980 graduating with an Associate Degree in Fashion Design in 1985. The past ten years have been a continuous evolution of his soul. He has integrated the Artist with the Fashion Designer—the physical with the spiritual, the traditionalist with the experimentalist, the past with the present and the present to the future.

"I have an ongoing expectation of myself and my art. This is to enlighten and stimulate the mind and the senses. If I have accomplished a fraction of this, then I have at least begun to achieve my goal. This is only the beginning."

Awards: *Manhattan Arts International*, Award of Excellence, 1994 & 1996; *Manhattan Arts International*, Award of Merit, 1995.

Publications: *Manhattan Arts International*, Artist in the 90s, Oct-Nov 1994; *Arts Monthly Newspaper*, Nov 1994 & Jan 1995.
Exhibitions: Abney Gallery, Soho, NY 1995
Price range of original work: $2000 - $5000.
2864 Broadway, San Diego, CA 92102 619·239·8058
HTTP://www.Abneygallery.com
Represented by *Darin Kaye*, 75 West End Ave #P24B, New York, NY 10023 212·764·2500

KUEI-CHUAN WEN

78 *Fly to Sky*
Oil on canvas, 24x48". Artist's collection.

78 *Books*
Oil on canvas, 30x40". Private collection.

Kuei-Chuan Wen was born in Taiwan in 1966, where he attended art school. He received his BFA from Chinese Culture University in 1991. He came to San Francisco to study painting in the graduate program at the Academy of Art College in 1993, where he received his MFA. He has won several awards for his artworks and has had many gallery shows throughout the U.S. and Taiwan. His works are exhibited and collected internationally.

In his recent works, he describes impossible or symbolic worlds in metaphorical sense. The events in his works are not far from ordinary reality. He tries to catch his feelings, capture his spirit, pursue the intense but irrational reality of a dream through the combination of realistic and unbelievable elements. Many symbols are ambivalent and can present themselves in his dreams, in either a positive or negative role. There are several elements represented in his work, such as self-portrait, tree, door, sun and moon, candle, human body, flying things, egg and shadows.

Price range of original work: $2800 - $4000.

1501 Lincoln Way #402, San Francisco, CA 94122 415·664·7883 Telephone/Fax

BARBARA WILDER

76 *Late Autumn in the Poconas*
Pastel, 19 1/2 x 12 1/2". Artist's collection.

Barbara Wilder's vibrant pastels, rich oils and soft watercolors all express her passion for the natural world. Her intuitive grasp of the nuances of light and color are revealed through her impressionistic sensibilities.

She is able to capture the delicate and fleeting changes of nature's beautiful rhythms. Inspired by a scene, she immediately sets up her equipment and works until dark. Her 'scapes' also include city scenes from her travels and interiors. Her other accomplishments include murals, miniatures and prints.

She has exhibited her work in museums and galleries throughout the U.S. and her work has been included in private and corporate collections. Recently, Wilder received her MA in Art Education from Brooklyn College. She has been an educator for most of her life, concentrating on Art Education. She was Director of a Museum-in-a-School. She has provided art instruction for adults and children in her studio, as well as art therapy to children diagnosed with psychiatric and learning disorders.

1902 Audubon Dr, Hanahan, SC 29406 803·569·2509

SHIR WOOTON

46 *Best Ride Ever*
 Pastel, 29x20¾". Artist's collection.

Shir Wooton has a BFA from Ohio University and has done graduate-level work at West Virginia University. She has won several awards for her graphic designs.

Her series of fine art pastoral scenes is composed on location and enhanced to show the beauty, peace and solitude provided by nature herself. No litter, no forest destruction, no crowded highways, no strip mining—just the sanctuary of the mountains. "All art cannot be a cause/action proposal. We need to treat ourselves to pleasing images which inspire dreams and create pleasant feelings. If we take care of what we have, we can have this. This is how things could really be—not a dream—but a reality."

She was one of the winners in the 8th edition cover contest for the *Encyclopedia of Living Artists*, as well as one of the runner-ups for the 9th edition.

Price range of original work: $1000 - $3000.

117 Granville Ave, Beckley, WV 25801 304·252·5808
304·787·9878 304·255·5041 Fax E-mail: shir@cwv.net

ZHAOMING WU

53 *Dancing with Illumination*
 Acrylic, 36x48". Artist's collection.

53 *Evening Bell*
 Acrylic, 48x36". Artist's collection.

114 Day Dream
 Acrylic, 30x40". Artist's collection.

Zhaoming Wu has exhibited worldwide. His approach to art is both aesthetic and technical, abstract and realistic. He believes the visual medium is capable of expressing things beyond intellectual ideas. His works are for those who are not afraid of beauty.

Awards: Finalist in 1995 *Artist's Magazine*; First prize "The Art of the Human Body" in California; Merit award Eastbay Watercolor Society, CA; Outstanding award, 6th National Exhibition Beijing, China and many others.

Exhibitions: California Museum of Art; Art Asia International Exposition, Hong Kong; Syllarethy Gallery, Scotland; National Museum of Fine Art, Beijing, China; Ge Shan Gallery, Taiwan; Shanghai Museum of Fine Art, Shanghai.

Bibliography: *Who's Who in North American Art*; *The Famous Figures of Contemporary Arts Circles in China*; *The World Famous Chinese Artists '96*. He is author of the *Modern Factors in Neo-Realism* and *The Head Painting*.

Public collections: Museum of Fine Art, Guangdong, China; The Westin St Francis, San Francisco, CA; Westin Tokyo, Japan and many others.

Price range of original work: $5000 - $15,000.

529B 42nd St, Oakland, CA 94609 510·428·2340

MARK A YAMIN

2 *Lollipop Factory*
 Pastel and pencil, 24¼x17⅛". Artist's collection.

Mark A Yamin was born in Michigan in 1952. After a career change and move to Naples, Florida in 1992, he began creating abstract art, utilizing the mediums of pastel and pencil. Self-trained, Yamin has created contemporary pieces on rag paper with an extraordinary, recurring trait: bold, deep and rich color that harmonizes and is pleasing to the eye.

His artwork is being actively shown around the country, and has been displayed at selected fundraisers. His pieces have been sold for private collection both domestically and internationally. Prices furnished upon request.

745 High Pines Dr, Naples, FL 34103-2800
941·649·7071 Telephone/Fax

The Zen Kiss by Jeff Chun

PEGGY ZEHRING

39 *Uxmal*
 Mixed media on handmade paper, 32x72".
 Artist's collection.

39 *Egyptian Meets Hopi*
 Mixed media on handmade paper, 30x66".
 Artist's collection.

Peggy Zehring creates mixed media collage paintings which recall long-buried Old Truths. She finds these Truths by traveling to archeological sites around the world. Her work is done intuitively so she is often unaware of what she's discovered until it manifests as a piece of art. Zehring enjoys experimenting with materials which are of the earth or have been softened and aged by it: ash, sand, chalk dust, rusted metal, disintegrating plastic...acrylic mediums and paint hold everything together.

She teaches workshops at retreats on beautiful islands near Seattle, both in the Summer and Fall—the emphasis being on creativity, originality, and truth seeking ideas.

She's derived from the Kandinsky-inspired fine arts program at the University of Illinois in Chicago.

Her work can be seen and/or purchased from her studio, the Seattle Art Museum Sales and Rental Gallery or in Colorado at PO Box 967, LaVeta, CO 81055.

Price range of original work: $350 - $4999.

832 31st Ave S, Seattle, WA 98144 206·328·4825

LOUIS F ZYGADLO

30 *If the Walls Could Dance*
 Oil on plastic, 40x72". Artist's collection.

30 *Room with a View*
 Oil on plastic, 40x72". Artist's collection.

Louis F Zygadlo is a self-trained artist, utilizing a background in plastics engineering to develop a library of over 1400 colors. These colors, produced of refined oil, combined with painting on plastic, enable him to achieve a superior blending surface. These are used in harmony with an ongoing exploration of a painting perspective which he calls 'Dimensionalism' in which the main characteristic is to make the piece appear more three-dimensional. In so doing, he paints three-dimensional abstract forms, placing them within the boundaries of realism, yet remaining abstract in essence. His style has become highly recognizable, and this combined with the technical aspects make his work truly unique in both color and form. If The Walls Could Dance and Room with a View are part of a new body of work which was inspired by five years of living in Wisconsin and walking in the silence of star-filled nights. These memories are kept within him and continue to be a guiding force.

403 E 3rd St, Sandwich, IL 60548-1606 815·786·6662
E-mail: lzygadlo@PRAIRIENET.COM
http://www.prairienet.com/lzstudio/
Represented by *Vedanta Gallery*, 119 N Peoria #3C, Chicago, IL 60607 312·432·0708

Comet by James Eugene Albert

ALPHABETICAL INDEX

James Eugene Albert	10-11, 140	Barbara Glander	28-29	Deannie Meyer	55
Luciana Amirgholi	49	Lou Grawcock	101	Frances Middendorf	107
Michelle Angers	129	Jackie Greber	40	Denis Milhomme	70
Andrew Annenberg	103	Mark Gudmundsen	87	Alex Mizuno	74
Chris Apostle	20	Lois Hannah	83	Crystal Moll	105
Ernie Applewhite	12	Patricia Hausmann	136	Rosemary Morison	122
Garin Baker	84	Rosemary Hendler	13	Kristina Muhic	138
Miguel Barbosa	38	Heli Hofmann	102	Julie K Neva	48
Billy Barton	92	Debee L Holland-Olson	43	Joela Nitzberg	96
Bates	64-65	Alvin C Hollingsworth	18-19	Sylvia Obert-Turner	54
Fran Beallor	63	George E Homsy	68-69	Marcelle Harwell Pachnowski	79
Ronald Belanger	99	Mark Hopkins	124	Peggy Palletti	72, 123
Bruce Bennett	56	Frank Jalsovsky	26-27	Christiane Pape	97
Orna Benshoshan	47	Jian-Kang Jin	96	Lee Park	72
Carol Bernard	135	Marnie Johnson	1, 141	John V Partridge	90
Robert G Bertone	Cover	Lisa Jones-Moore	50	Mark Pelnar	93
Bill Bracey	84	Maria delia Bernate Kanter	42	Yali Peng	131
Jennette Brice	59	Robert F Kauffmann	132	Fern L Phillips	51
Erik Bright	130	Eva Keky-Magyar	14-15	Hugh Polder	25
Kurt C Burmann	70	Betsy M Kellum	93	Gayle Pritchard	3
Nagi Chami	106	Pati Kent	134	Barbara Rachko	23
Humberto Chau	24	Hee Sook Kim	22	Tanya Ragir	125
Ghambaro Cheung	104	Bill King	121	Ennio Romano	77
Alex Chubotin	118	M A Klein	126	Sy Rosenwasser	133
Jeff Chun	139	Robert Kogge	57	Jennifer Rothschild	58
Judita Zilius Clow	44	Gilda Kolkey	98	Manabu Sakaguchi	33
Julie Kramer Cole	54	Marek Kosiba	41	Doug Scott	88-89
Jack D Cowan	32	Norbert H Kox	80	Philip Sherrod	8
Ivo David	34	Bonnie Kwan Huo	74	Yvette Sikorsky	16
Mabel Martin Davidson	86	Silja Talikka Lahtinen	36-37	Lidia Simeonova	75
Janet Delfosse	51	Wendy Lane	9	Mark T Smith	Back cover
Nancy Delgado	17	Ovidiu Lebejoara	81	Timothy Stafford	31
B Douglas Dewar	71	Darnell Lee	52	R M Sussex	100
Shu-Tang Dong	66	Edward Hong Lim	40	Gloria Tacheenie-Campoy	4
Donna Duguay	73	Ann James Massey	62	Frank Taira	85
Richardene Dymond	83	Lorna Massie	21	Joanne Turney	144
Darcy Dziedzic	108	Rhonda McEnroe	94	Faith Tyler	117
Birdell Eliason	82	Renee McGinnis	111	Jon Van Brunt	67
Sy Ellens	76	Julie McGuire	5	George Alphonso Walker	7
James Ellison	107	Grace Merjanian	91	Kuei-Chuan Wen	78
Dempsey Essick	95			Barbara Wilder	76
Nouzha Evans	98			Shir Wooton	46
William M S Fang	66			Zhaoming Wu	53, 114
William M Fegan	45			Mark A Yamin	2
Perla Fox	86			Peggy Zehring	39
Veronica Galati	113			Louis F Zygadlo	30
Ludmila Gayvoronsky	12				
Patricia George	60-61				
Mitchell Gibson	35				
Adrienne Gillespie	100				

Contemporary Eve by Marnie Johnson

GEOGRAPHICAL INDEX

ARIZONA
Kurt C Burmann　70
Mitchell Gibson　35
Sylvia Obert-Turner　54
Gloria Tacheenie-Campoy　4

CALIFORNIA
James Eugene Albert　10-11, 140
Billy Barton　92
Carol Bernard　135
Nagi Chami　106
Jeff Chun　139
B Douglas Dewar　71
Shu-Tang Dong　66
Donna Duguay　73
Richardene Dymond　83
James Ellison　107
Nouzha Evans　98
Patricia George　60-61
Adrienne Gillespie　100
Mark Gudmundsen　87
Patricia Hausmann　136
Rosemary Hendler　13
Heli Hofmann　102
Debee L Holland-Olson　43
Pati Kent　134
Bill King　121
M A Klein　126
Ovidiu Lebejoara　81
Edward Hong Lim　40
Grace Merjanian　91
Deannie Meyer　55
Denis Milhomme　70
Alex Mizuno　74
Kristina Muhic　138
Julie K Neva　48
Joela Nitzberg　96
Peggy Palletti　72, 123
Lee Park　72
John V Partridge　90
Fern L Phillips　51
Tanya Ragir　125
Sy Rosenwasser　133
Faith Tyler　117
George Alphonso Walker　7
Kuei-Chuan Wen　78
Zhaoming Wu　53, 114

COLORADO
Bates　64-65
Julie Kramer Cole　54
Jackie Greber　40

FLORIDA
Jack D Cowan　32
Maria delia Bernate Kanter　42
Mark A Yamin　2

GEORGIA
Silja Talikka Lahtinen　36-37
Darnell Lee　52
Julie McGuire　5

HAWAII
Andrew Annenberg　103
Jennifer Rothschild　58

IDAHO
R M Sussex　100

ILLINOIS
Birdell Eliason　82
Gilda Kolkey　98
Marek Kosiba　41
Renee McGinnis　111
Mark Pelnar　93
Hugh Polder　25
Louis F Zygadlo　30

INDIANA
Lou Grawcock　101
Rhonda McEnroe　94

KENTUCKY
Mabel Martin Davidson　86

MARYLAND
J Delfosse　51
Perla Fox　86
Crystal Moll　105

MASSACHUSETTS
Orna Benshoshan　47

MICHIGAN
Sy Ellens　76
Lidia Simeonova　75

MINNESOTA
Wendy Lane　9
Yali Peng　131

MISSISSIPPI
Ernie Applewhite　12

NEW HAMPSHIRE
Ludmila Gayvoronsky　12

NEW JERSEY
Robert G Bertone　Cover
Ivo David　34
Barbara Glander　28-29
Robert F Kauffmann　132
Robert Kogge　57
Timothy Stafford　31

NEW MEXICO
Marnie Johnson　1, 141
Doug Scott　88-89

NEW YORK
Chris Apostle　20
Garin Baker　84
Fran Beallor　63
Bruce Bennett　56
Humberto Chau　24
Ghambaro Cheung　104
Veronica Galati　113
Alvin C Hollingsworth　18-19
George E Homsy　68-69
Mark Hopkins　124
Jian-Kang Jin　96
Hee Sook Kim　22
Lorna Massie　21
Frances Middendorf　107
Marcelle Harwell Pachnowski　79
Christiane Pape　79
Philip Sherrod　8
Yvette Sikorsky　16
Mark T Smith　Back cover
Frank Taira　85
Jon Van Brunt　67

NORTH CAROLINA
Jennette Brice　59
Dempsey Essick　95

OHIO
Gayle Pritchard　3

OREGON
Darcy Dziedzic　108

PENNSYLVANIA
Joanne Turney　144

RHODE ISLAND
Erik Bright　130

SOUTH CAROLINA
Barbara Wilder　76

TEXAS
Luciana Amirgholi　49
William M Fegan　45
Ann James Massey　62

VIRGINIA
Bill Bracey　84
Betsy M Kellum　93
Barbara Rachko　23

VERMONT
Judita Zilius Clow　44

WASHINGTON
Alex Chubotin　118
Nancy Delgado　17
Lisa Jones-Moore　50
Peggy Zehring　39

WEST VIRGINIA
Shir Wooton　46

WISCONSIN
Norbert H Kox　80

CANADA
Ronald Belanger　99
William M S Fang　66
Michelle Angers　129
Lois Hannah　83
Frank Jalsovsky　26-27
Rosemary Morison　122
Bonnie Kwan Huo　74

GERMANY
Eva Keky-Magyar　14-15

ITALY
Ennio Romano　77

JAPAN
Manabu Sakaguchi　33

PORTUGAL
Miguel Barbosa　38

MEDIUM INDEX

ACRYLIC
Luciana Amirgholi	49
Michelle Angers	129
Miguel Barbosa	38
Ronald Belanger	99
Carol Bernard	135
Jennette Brice	59
Kurt C Burmann	70
Mabel Martin Davidson	86
Shu-Tang Dong	66
Richardene Dymond	83
Sy Ellens	76
William M S Fang	66
Mitchell Gibson	35
Mark Gudmundsen	87
Alvin C Hollingsworth	18-19
Maria delia Bernate Kanter	42
Marek Kosiba	41
Darnell Lee	52
Julie McGuire	5
Kristina Muhic	138
Julie K Neva	48
Manabu Sakaguchi	33
Yvette Sikorsky	16
Lidia Simeonova	75
Gloria Tacheenie-Campoy	4
Joanne Turney	144
Zhaoming Wu	53, 114

AIRBRUSH
Timothy Stafford	31

BRONZE
Alex Chubotin	118
Lois Hannah	83

CASEIN
Hugh Polder	25

CERAMIC
Erik Bright	130

COMPUTER
James Eugene Albert	10-11, 140
Ernie Applewhite	12
Rosemary Hendler	13

ENCAUSTIC
Eva Keky-Magyar	14-15

ENGRAVING
Patricia Hausmann	136

FIBER
Gayle Pritchard	3

GLASS
Bill King	121

GOUACHE
Frances Middendorf	107

MARBLE
Doug Scott	88-89

MIXED MEDIA
Jackie Greber	40
Pati Kent	134
Hee Sook Kim	22
M A Klein	126
Peggy Palletti	72, 123
Christiane Pape	97
Lee Park	72
Mark T Smith	Back cover
Peggy Zehring	39

OIL
Andrew Annenberg	103
Chris Apostle	20
Garin Baker	84
Billy Barton	92
Bates	64-65
Fran Beallor	63
Orna Benshoshan	47
Robert G Bertone	Cover
Nagi Chami	106
Humberto Chau	24
Ghambaro Cheung	104
Jeff Chun	139
Jack D Cowan	32
Ivo David	34
Birdell Eliason	82
James Ellison	107
Nouzha Evans	98
William M Fegan	45
Veronica Galati	113
Ludmila Gayvoronsky	12
Patricia George	60-61
Adrienne Gillespie	100
Barbara Glander	28-29
Heli Hofmann	102
George E Homsy	68-69
Mark Hopkins	124
Jian-Kang Jin	96
Marnie Johnson	1, 141
Gilda Kolkey	98
Norbert H Kox	80
Silja Talikka Lahtinen	36-37
Ovidiu Lebejoara	81
Edward Hong Lim	40
Ann James Massey	62
Renee McGinnis	111
Denis Milhomme	70
Crystal Moll	105
Joela Nitzberg	96
Sylvia Obert-Turner	34
Marcelle Harwell Pachnowski	79
Mark Feinar	93
Fern L Phillips	51
Ennio Romano	77
Philip Sherrod	8
R M Sussex	100
Frank Taira	85
Jon Van Brunt	67
George Alphonso Walker	7
Kuei-Chuan Wen	78
Louis F Zygadlo	30

OIL PASTEL
Donna Duguay	73
Wendy Lane	9

PASTEL
Julie Kramer Cole	54
Janet Delfosse	51
Lou Grawcock	101
Debee L Holland-Olson	43
Lisa Jones-Moore	50
Betsy M Kellum	93
Alex Mizuno	74
Barbara Rachko	23
Faith Tyler	117
Barbara Wilder	76
Shir Wooton	46
Mark A Yamin	2

PENCIL
Bill Bracey	84
B Douglas Dewar	71
Robert Kogge	57

PHOTOGRAPHY
Bruce Bennett	56
Darcy Dziedzic	108
Yali Peng	131

PRINTMAKING
Frank Jalsovsky	26-27
Robert F Kauffmann	132
Lorna Massie	21

SCULPTURE
Tanya Ragir	125
Sy Rosenwasser	133

WATERCOLOR
Judita Zilius Clow	44
Nancy Delgado	17
Dempsey Essick	95
Perla Fox	86
Bonnie Kwan Huo	74
Rhonda McEnroe	94
Grace Merjanian	91
Deannie Meyer	55
Rosemary Morison	122
John V Partridge	90
Jennifer Rothschild	58

Grace by Joanne Turney